IMAGES
of America

CLIFTON

IMAGES
of America

CLIFTON

Lynne Garvey-Hodge

ARCADIA
PUBLISHING

Published by Arcadia Publishing
Charleston SC, Chicago IL, Portsmouth NH, San Francisco CA

Printed in the United States of America

Library of Congress Catalog Card Number: 2007942383

For all general information contact Arcadia Publishing at:
Telephone 843-853-2070
Fax 843-853-0044
E-mail sales@arcadiapublishing.com
For customer service and orders:
Toll-Free 1-888-313-2665

Visit us on the Internet at www.arcadiapublishing.com

To my father, the late Jack E. Garvey, who gave me my earliest and "past" history. To my daughter, Hilary Lynne Hodge, who has given me my current and "future" history. And to the late Nan Netherton, who helped me fall in love with the history of Clifton and Fairfax County, Virginia.

CONTENTS

ACKNOWLEDGMENTS

Since the vision of this book began, countless people have helped contribute information, photographs, stories, insights, documents, suggestions, resources, and inspiration. They include, but are not limited to, the Fairfax City Library Virginia Room headed by Suzanne Levy, as well as Susan Hellman; Julia Randle from the archives of Virginia Theological Seminary's Bishop Payne Library; the Bull Run Civil War Roundtable, led by John McAnaw; the Fairfax Railroad Museum, headed by Joan Rogers with board members Ron Beavers and Bill Etue; and members of the Fairfax County Park Authority: Michael Rierson, Liz Crowell, C. K. Gaille, Mike Johnson, and John Rutherford. I extend tremendous gratitude to Fairfax County's elected leaders, Gerry Connolly, Elaine McConnell, Pat Herrity, George Barker, and Tim Hugo; members of the Fairfax County History Commission and especially Naomi Zeavin, Barbara Naef, Esther McCullough, Don Hakenson, the late Dr. Don Senese, Bob Heittman, and the late Edith Sprouse; friends and neighbors of Clifton, including Tom Peterson, Jim and Jennifer Chesley, Margo Buckley Khosravi, Wayne Nickum, Malcolm McIntyre, Emmett and Ellen Barrett, Betty Boyd, Douglas Detwiler, Tom and Willard Webb, Helen and Chuck Rusnak, Lee Hubbard, Sharon Cavileer, Alicia Harvey, Kathy Baber, William Baumbach, Steve Bittner, Marla Hembree, Faye Karns, Darnell Hoose, Paul Sangster, Morag Cole, Deb Crosier, Betty Bosanko, Harvey Mathers, Sherry Zachary, Berniece Colvard, Andy Morse, Sue Buckley, and the descendants of Dr. Kate Waller Barrett. Personal friends and family who "cheerleaded" me throughout this writing include Hilary Lynne Hodge, Marion C. Garvey, David M. Goetz, Win Meiselman, Retta Yorns, Janet McCormick, Sharron Wofsy, and Gail Kessler. Finally, photographic and electronic assistance was ably provided by photographer and personal friend Ed Parker and computer wizard Tim Gallagher. During the writing and research of this book, amazing couplings and connections became apparent between my hometown of Cleveland, Ohio, Clifton, and the National Florence Crittenton Mission. I also wish to thank Patrick O'Neill, who stood by me during a whirlwind of challenges during the writing and preparation of this manuscript. Finally, thanks to my faith community, Burke Presbyterian Church, who ever remind me of God's eternal and everlasting love.

INTRODUCTION

The historic village of Clifton, Virginia, in southwestern Fairfax County has been home to peoples of North America for more than 15,000 years. Between 12000 BC and 7500 BC, increased temperatures resulted in a warmer climate, increasing sea levels and new inner-coastal waterways and tributaries; with a more temperate climate, the Native American presence increased significantly. The weapons and tools used by local native peoples were carved out of quartz and stone and can still be found in great numbers in the ground and along local creek beds. The Powhatan, Dogue, and Algonkian tribes roamed the land, finding plentiful wildlife.

In 1607, Englishman Capt. John Smith founded Jamestown, and the Native Americans who greeted him were a collection of tribes found throughout the Piedmont region. Their agriculturally oriented way of life reflected the growing of corn, squash, beans, and tobacco. They hunted, fished, and gathered berries, nuts, roots, and shellfish. They fashioned bowls out of the local soapstone and carved stone and quartz projectile points used for hunting and food preparation.

By 1643, the English had claimed an immense amount of land north and west of the James River, which became eight shires defined in 1634 by the Virginia House of Burgesses. These counties were later divided into smaller ones, one called Chicacoan, of which present-day Fairfax County was a part. Fairfax was also part of several other counties, as the dividing continued, including Northumberland (1645), Westmoreland (1653), Stafford (1664), Prince William (1730), and finally Fairfax in 1742. Much larger than its current size, Fairfax once included current Arlington and Loudon Counties and the cities of Falls Church, Fairfax, and Arlington. The county's first courthouse was located near Tysons Corner, then in 1752 moved to Alexandria, where it remained until 1800. In 1800, it moved to Providence, now Fairfax City, eight miles north of Clifton.

Popes Head Creek, identified by 1710 in *Northern Neck Land Grants*, was a possible reference to a place near London, England's theater district at Fleet Street and Chancery Lane or poet Alexander Pope's villa built at Twickenham, England, in 1719. During the villa's construction, a subterranean spring was discovered, making the sound of tinkling waters, and Pope was quoted as saying, "Were it to have nymphs as well—it would be complete in everything." Pope was a freemason and member of the Grand Lodge of England, and today Acacia Lodge No. 16 rests on the shore of Popes Head Creek.

Charles II granted the land between the Potomac River and the Rappahannock to the Culpepper family, and by 1690, the Fairfax family controlled the land. In 1737, Thomas, Sixth Lord Fairfax, came to Virginia and installed his cousin, William, as his private land agent. By 1745, the English Privy Council had confirmed 5,282,000 acres to Lord Fairfax. By 1710, the Clifton area was being bought by Englishmen, including John Waugh (2,800 acres) and Thomas Hooper (900 acres) between Popes Head Creek and Johnny Moore Run. Four hundred acres were granted to Francis Beavers in 1728, and Richard Kirtling (Kirkland) Jr. received 290 acres including a water gristmill on Popes Head Creek. These four English gentlemen were the first colonists in the Clifton area.

By 1760, the Clifton area was owned by the families of Daniel Thomas, Frances Thornton, Jane Turley, James Warden, Leonard Dozier, Tyler Waugh, James Waugh, and William Bayly.

Others included Beckwith, Pollard, Grant, Monk, Henderson, Payne, Davis, Wickliffe, and Gibbs. Marmaduke Beckwith the Younger of Richmond County, Virginia, purchased 424 acres from Charles and Ann Tyler. Within a century, his ancestors assembled 1,200 acres on Popes Head Creek, eventually held by William E. Beckwith. Names still associated with Clifton reflect earlier landholdings, including the Kincheloes. Upon the death of Nancy Dye, the Kincheloes purchased the upper Union Mill on Popes Head Creek. In 1844, 1847, and 1851, the Buckley family purchased land along Johnny Moore Run. James Sangster bequeathed to sons James and Edward land along Popes Head and Wolf Run in 1846 and 1848. John Detwiler, from Chester County, Pennsylvania, purchased Union Mills south of Popes Head and near Bull Run just before the Civil War.

With progress and growth, a need arose for increased freight and passenger travel. In 1848, private investors incorporated the Orange and Alexandria Railroad (O&A) Company. This railroad line was initially founded to expedite the transport of agricultural products such as tobacco and wheat from central Virginia to the eastern markets and manufactured goods from east to central Virginia. Passenger travel was also encouraged. Chartered by the General Assembly on May 28, 1848, to run between Alexandria and Gordonsville, the O&A began construction in 1850 and completed in April 1854 when it was connected with the Virginia Central Railroad in Orange County. In 1860, a southern extension was added between Charlottesville and Lynchburg, allowing connections to the Virginia and Tennessee Railroad and the South Side Railroad, enhancing the O&A success and connection with the Manassas Gap Railroad to the Shenandoah Valley at Tudor Hall. This increase in transportation meant an increase in commerce for farmers, enhancing Alexandria's position as a thriving seaport. Passengers could travel in eight hours from Washington to Lynchburg—a trip that previously took three days by stagecoach. Stop number six on the O&A was known as Sangster's Station and eventually Devereux Station.

The Orange and Alexandria Railroad supplied troops for the Union army and was incorporated into the U.S. Military Railroad system, carrying soldiers from New York, Ohio, Massachusetts, New Hampshire, Pennsylvania, and various Northern states. Harrison G. Otis, the "Father" of Clifton, may have traveled this line as a Union soldier when he first laid his eyes on the area and found a welcome terrain in which to cultivate grapes.

Numerous Civil War battles were fought near the O&A, the only rail link between Washington, D.C., and Richmond. It drew Union army troops to the First Battle of Bull Run at Manassas Junction in 1861. Confederate major general Thomas J. "Stonewall" Jackson attacked it in order to draw the Union into the Second Battle of Bull Run. Near Clifton, the Battle at Sangster Station on December 17, 1863, occurred during a blinding rain and ice storm.

Dozens of area men signed up to support the Confederate cause, including names still associated with this land: Capt. James C. Kincheloe; Sgt. William S. Kincheloe; R. S. Kincheloe; Isaac, L. W., and Thomas Fairfax; Cornelius Beach; Addison, Henry E., and J. B. Davis; Newton J. Dulhany; John F. and Zachariah Mayhugh; George and James H. Pettit; Thomas Simpson; James E. Stone; the Tillet family: George W., Henry T., and John R.; George W. Wilt; Lewis Woodyard; John M. Ford; Thomas F. Adams; Joseph Crouch; and John Elzey. Some of these men served with John Singleton Mosby, the "Gray Ghost."

On April 22, 1862, John Henry Devereux became superintendent of U.S. Military Railroads operating out of Alexandria, Virginia. He ordered improvements to the Alexandria depot complex, enlarged the engine house, purchased engines, installed switches to accommodate an increase in rail traffic, and constructed a machine shop to provide repair services to the locomotives. He ordered the repair of tracks and managed the men underneath him in a fair manner. President Lincoln looked favorably upon his work. Devereux served successfully between 1862 and 1864 under six commanding generals of the Union army. One superior, Herrman Haupt, came to highly appreciate and respect Devereux. Devereux was clear about the type of man to hire, and his high standards brought him respect and likability. A new locomotive was named the *J. H. Devereux*, and the sixth stop on the O&A Railroad between Fairfax Station and Union Mills was named Devereux Station. In 1864, Devereux gave up his fine work in support of the Union war effort

by accepting the position of superintendent of the Cleveland and Pittsburgh Railroad, nearly doubling his federal position salary and allowing him to rejoin his family and newborn daughter in Cleveland, Ohio.

In 1863, large landowner/plantation owner William Beckwith died, the last of his line, leaving 200 acres south of the O&A to his 16 slaves, who were simultaneously freed. The balance of his estate was sold after the war by the executors of his will, Thomas N. Stewart and John Bronaugh. In February 1868, northerner Harrison G. Otis purchased 1,001 acres of land on Popes Head Creek and the O&A Railroad. His brother, J. Sanford Otis, joined him, and they began the early development of Clifton. Records indicate they were from either Ontario, New York, or Clifton, New Jersey, hence the name change from Devereux Station to Clifton Station.

By December 1870, work began on the Clifton Hotel, the deed stating that into perpetuity the back parcel of land should house a Presbyterian church. On December 10, 1870, the Clifton Presbyterian Church was organized and the following elected as trustees: E. T. Simpson, H. B. Nodine, Lewis Quigg, William E. Ford, J. S. Otis, and Charles F. Newman. With an official railroad station, formal house of worship, a beautifully appointed hotel, nearby spring water, and a temperate climate, this little thriving place of commerce was soon to grow into a picturesque village changing little in the next 130 years, making it Clifton, "the Brigadoon of Virginia."

One

NATIVE AMERICAN INFLUENCE

The Clifton area was populated by Native Americans 15,000-plus years ago. Soapstone bowls, knife points, sharp projectile points for spears, banner stones, arrowheads, and flint carvings have been found nearby. When Captain Smith arrived in Jamestown, some 13,000–14,000 Powhatan Indians were living in the Chesapeake Bay region under a tribal head, Powhatan, who led a nation of 30 tribes. The marriage of Powhatan's daughter, Pocahontas, to settler John Rolfe in 1614 ensured three years of peace. When Pocahontas died in 1617 and Powhatan in 1618, peace ended. Their new leader, Opechancanough, staged an attack on English settlements, resulting in settler retaliation, which continued for a decade with Native American men, women, and children captured and killed by the English. In 1644, a final raid was launched against the English, hundreds of colonists were killed, and Opechancanough was shot and killed. By 1669, there were only 1,800 Powhatan Indians in the Chesapeake area. The Native Americans lived in large villages enclosed within wooden stockades lining the Potomac River. Smaller satellite villages were found inland on tributaries. The Dogue, Patawomeka, and Piscataway Indians lived in the Fairfax County region. When the northern Maryland government invited the Susquehannock Iroquoian tribe into the Chesapeake Bay area, conflicts resulted, leaving tribal remnants roaming through the region terrorizing other Native American and European settlers. By the 18th century, the land around Clifton was being surveyed and occupied by European families.

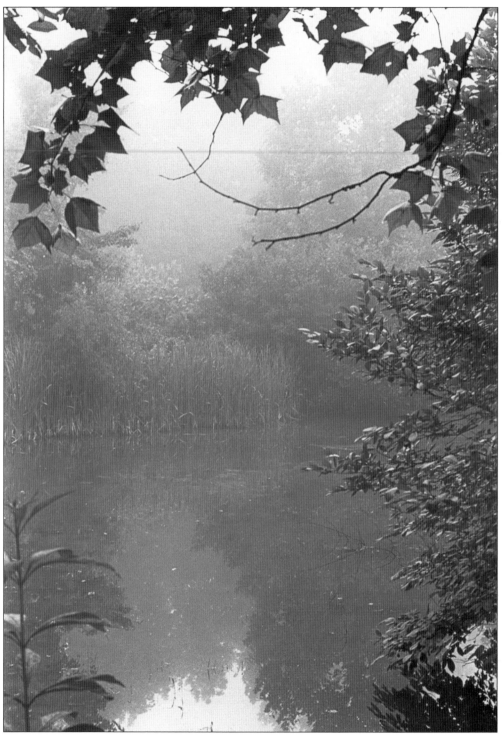

The beauty of Popes Head Creek is captured on a misty 1970 morning. This area was hunted and lived on by Native Americans 15,000 years ago, and remnants of their campfires and hunting tools are found throughout the region. (Courtesy Virginia Room, Fairfax City Library.)

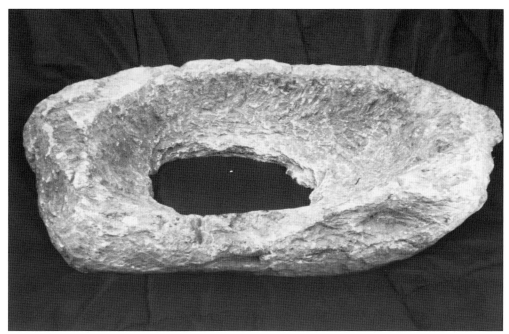

The "steatite" soapstone bowl above was found on Union Mills Road in Clifton, likely from the Balmoral Greens area. Soapstone was used in many ways, including as weaponry and as talc for explosives. Soapstone quarries line Popes Head Creek. Native Americans carved ground imbedded stone. Each spherical projection was cut off and carved out, creating a bowl to carry food, water, herbs, or ceremonial items. This piece dates from the Savannah River/Woodland period, approximately 3700–4500 BC. (Courtesy Kristin and Steve Hermsmeyer.)

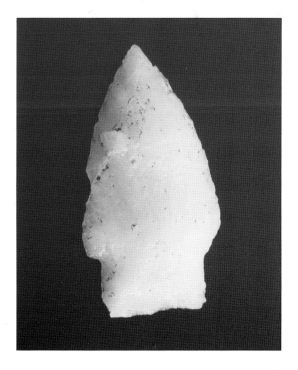

This quartz projectile knife point was found near the soapstone bowl, which may indicate they were used for ceremonial purposes. It would have fit onto a stemmed knife tool and may date to 500 AD. Numerous similarly shaped projectile points have been found along the banks of Popes Head Creek. (Courtesy Kristin and Steve Hermsmeyer; information courtesy John Rutherford, Fairfax County Park Authority.)

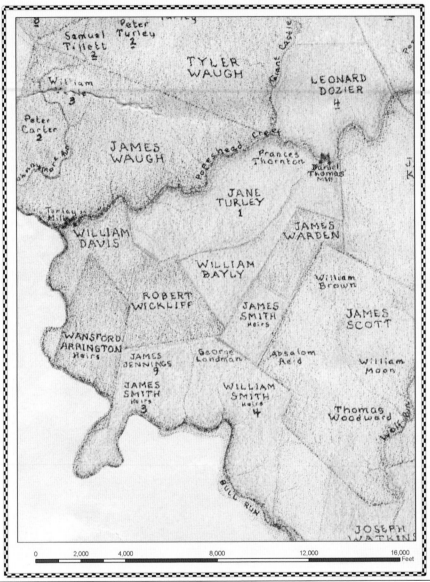

Beth Mitchell's 1760 map of Fairfax County depicts the Clifton area. The "M" indicates a mill on the property of Daniel Thomas, who petitioned and received permission to build on Popes Head Creek in 1749. The gristmill was the first of several at this location operating until the 20th century. Note the "M" above William Davis's property. "Turley's Mill" was indicated on an 1862 map. On an 1878 Hopkins map, the mill is marked as belonging to or inhabited by John Landis. The mill is depicted in 1886 on Shipman's map as "Detwiler's Mill." John Detwiler married Elizabeth Halteman Huntsberger in 1851 in Pottstown, Pennsylvania. Detwiler's saw and gristmill on Johnny Moore Creek operated from 1886 to 1910. (Courtesy Fairfax County Park Authority and Fairfax County History Commission.)

Clifton and Vicinity 1937 Aerial View
1860 Land Owners

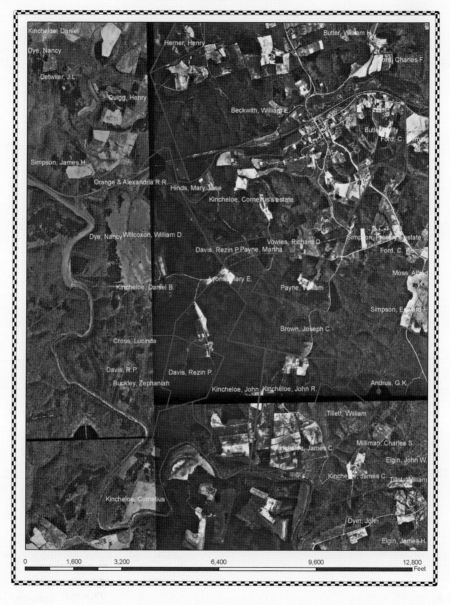

This 1937 aerial view of Clifton indicates 1860 landowners. Note the large William Beckwith plantation and considerable holdings of the Kincheloe, Payne, Ford, Detwiler, Quigg, Tillett, Cross, Simpson, Dyer, Davis, and Buckley families. Many of theses families have descendants still associated with Clifton. Also shown are the Southern (formerly O&A) Railroad and Popes Head Creek. The intersection of Clifton and Newman Roads and the Clifton School sitting above the town can be seen. The area around Clifton was heavily devoted to farming, primarily dairy farming, until the mid-20th century. (Courtesy Fairfax County Park Authority.)

15

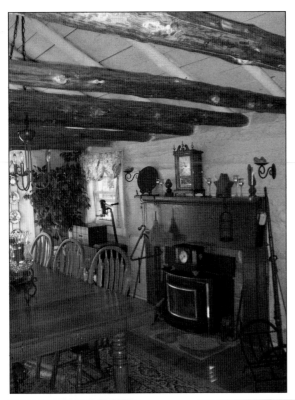

This home was composed of two log cabins built in the early 1800s. The dining room wood beams came from the nearby Detwiler family farm. The cabins were used by Union forces during the Civil War, and the original cabin shape is similar to a Union officer quarters at nearby Centreville, Virginia. (Courtesy Kristin and Steve Hermsmeyer.)

Two

CLIFTON AND THE CIVIL WAR

Chuck Mauro's book *The Civil War in Fairfax County* reads, "The citizens of Fairfax County occupied front row seats at the most horrific show this country has ever seen. Because of its position across the Potomac River on the doorstep of Washington, D.C., Fairfax County was heavily targeted by the Confederate army and defended with equal determination by the Union army. Fairfax was the first county in the south the Union army invaded, and the last it occupied."

In April 1861, Col. Robert E. Lee resigned his U.S. Army commission and traveled the O&A Railroad to Richmond, where he was placed in command of Confederate volunteers. In May, Lee chose Bull Run, near Clifton, as a base line to protect and defend Manassas Junction, where the O&A and Manassas Gap Railroads connected. Between 1861 and 1865, significant destruction, rebuilding, and protection of the O&A occurred between Fairfax, Clifton, and Culpeper. The Bull Run railroad bridge was destroyed and rebuilt seven times—more than any other bridge during the war. In 1862, John Henry Devereux was chosen as superintendent of the Union's O&A Railroad, where he served until 1864. Devereux supervised the building of the "Y," a railroad siding allowing a train to pull off and turn around from the main line at Devereux Station. In 1863, the Battle of Sangster Station occurred near Clifton along the O&A line. In his oral presentation, "The Railroads and the Civil War," Ron Beavers provides more detail: before the Overland Campaign, 6,000 head of cattle were sent weekly from Alexandria through Clifton to Brandy Station—1,200 head were sent daily, Friday through Tuesday. The O&A had 300 cattle cars. Quartermasters seized all flat and freight cars and within the first 24 hours busily went about sending on 1,800 head of cattle, an operation requiring constant employment of 300-plus men.

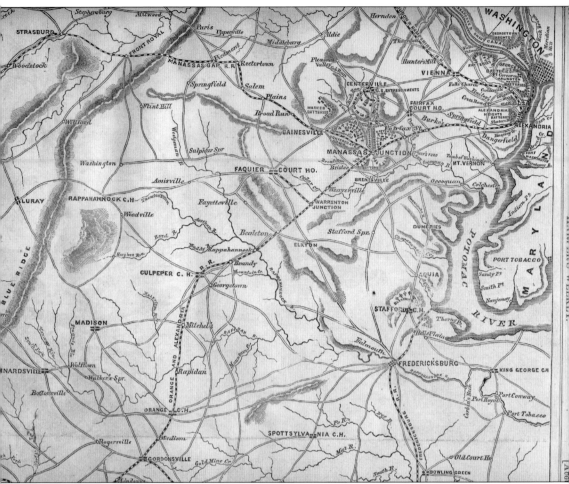

Just past Fairfax Station on the O&A Railroad line was unmarked Stop No. 6, indicated on the *Harper's Weekly* map from August 10, 1861. Confederate and Union forces roamed the area, variously destroying and defending the railroad lines. Union Mills and Sangster Station were adjacent railroad stops where significant Civil War engagements occurred. It is said that the area now home to Clifton changed hands from five to six times during the Civil War, alternating between Union and Confederate occupation. (Author's collection.)

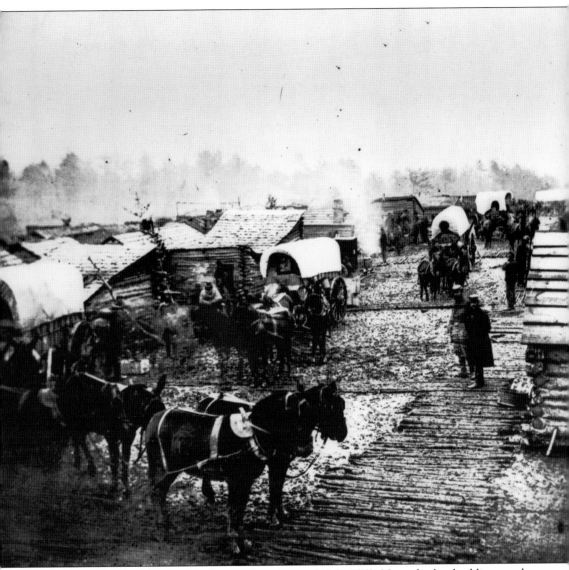

Union forces were at Centreville during the winter of 1861–1862. Note the log buildings and officer quarters, similar to the home on page 16. By the end of the war, disease and starvation had devastated both the Confederate and Union soldiers. (Courtesy Library of Congress.)

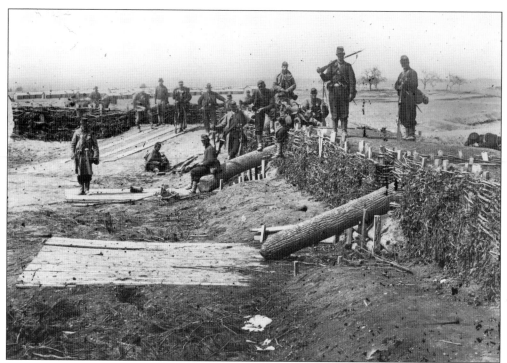

Federal troops at Centreville used Quaker guns, tree trunks painted and carved to look like cannons. The term comes from the Quakers' religious opposition to violence and war. (Courtesy Library of Congress.)

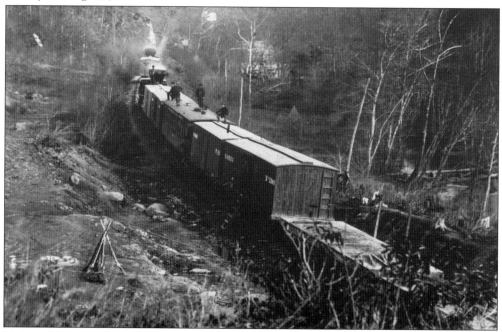

Union soldiers stand guard on a train of boxcars on the O&A Railroad near Union Mills. Food, animals, grain, clothing, and candles were but a few of the many items required to reach both the citizenry and the military troops. (Courtesy Library of Congress.)

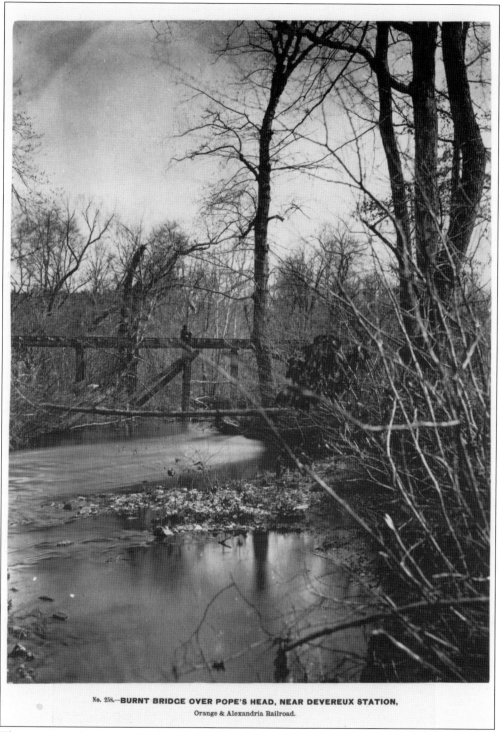

No. 258.—BURNT BRIDGE OVER POPE'S HEAD, NEAR DEVEREUX STATION,
Orange & Alexandria Railroad.

The remains of a burnt and destroyed railroad bridge over Popes Head Creek near Devereux Station are pictured here. There were five bridges in the near vicinity of Clifton, and the stone trestles still exist. (Courtesy Library of Congress.)

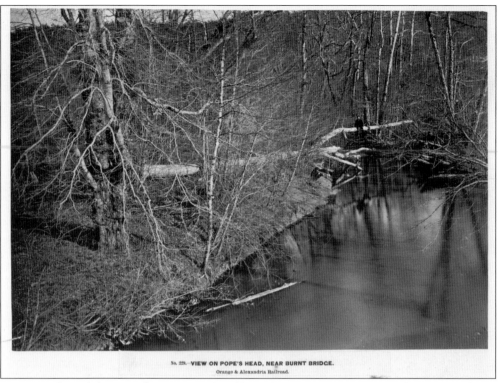

No. 229.—VIEW ON POPE'S HEAD, NEAR BURNT BRIDGE.
Orange & Alexandria Railroad.

Popes Head Creek lay near the O&A Railroad line close to Devereux Station. (Courtesy Library of Congress.)

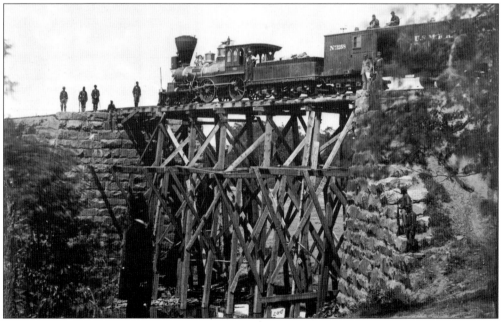

Shown in 1865, this bridge on the O&A Railroad was located in Fairfax County east of Clifton. The stone trestles still exist. Note the soldiers carefully standing guard in order to protect the freight and the wooden joists of the bridge. (Courtesy Library of Congress.)

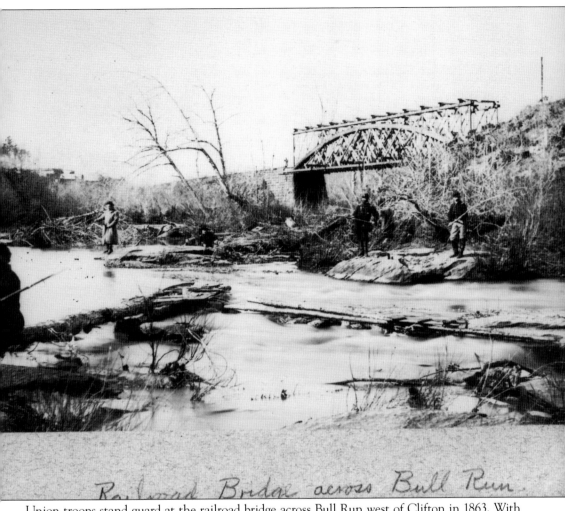

Railroad Bridge across Bull Run.

Union troops stand guard at the railroad bridge across Bull Run west of Clifton in 1863. With trestles made from wood, the bridges were an easy target for destruction by fire from both the Confederate forces and the Mosby Rangers, who rode with John Singleton Mosby, the "Gray Ghost." (Courtesy Library of Congress.)

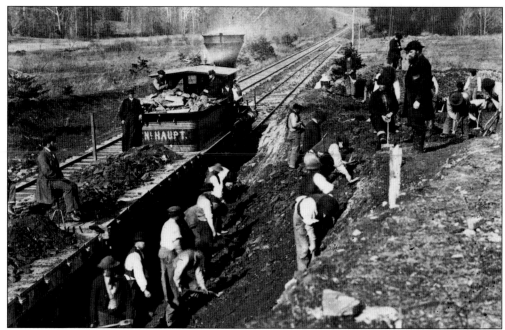

"General" John H. Devereux, with hat and beard, is supervising a construction site at Stop No. 6, eventually called Devereux Station, on the O&A Railroad in 1863. The men are excavating a "Y" (wye)—an additional side track to allow a train to pull off the main track and turn around. (Courtesy Library of Congress.)

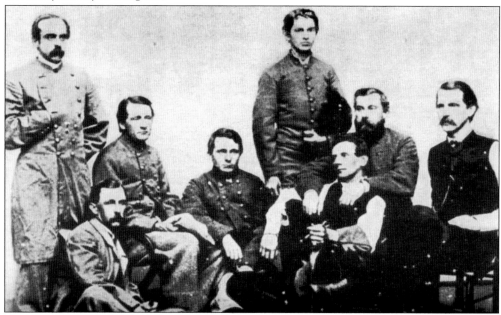

John Singleton Mosby, the "Gray Ghost," is seen with some of his Rangers. Mosby was quite familiar with the O&A Railroad near Clifton. Several of his men retired to Clifton after the Civil War and attended Clifton Baptist Church. From left to right are Rangers Dickson, Watkins, Mosby, Thomas, Smith, Carlisle, Carter, and one unidentified ranger. (Courtesy Don Hakenson and David Goetz.)

Camp 2d C.V.A. near Clifton Va Sept 11th 1864

$10.

o COLONEL WILLIAM FITCH, NEW HAVEN, CT.,

PAYMASTER-GENERAL OF THE STATE OF CONNECTICUT, OR HIS SUCCESSOR IN OFFICE:

At sight, or whenever due, pay *Saml Hunter* or order,

e *Seventh* payment of *Ten Dollars*, due me from the State, under "an Act in
ldition to an Act to provide for the organization of a Volunteer Militia, and to provide for the
ublic defense."

PAID

Saml Hunter

Company *"C"* 2d Regiment
Connecticut Volunteers. *Arty*

WITNESS,

Dwight McKilbourn Lieut.

This payment voucher for $10 was paid to Samil Hunter of the 2nd Connecticut Artillery on
September 11, 1864, in Clifton. This was the seventh payment voucher to Hunter, reflecting a
yearlong commitment to the Union cause. (Courtesy Mike Foley; gift to Lynne Garvey-Hodge.)

25

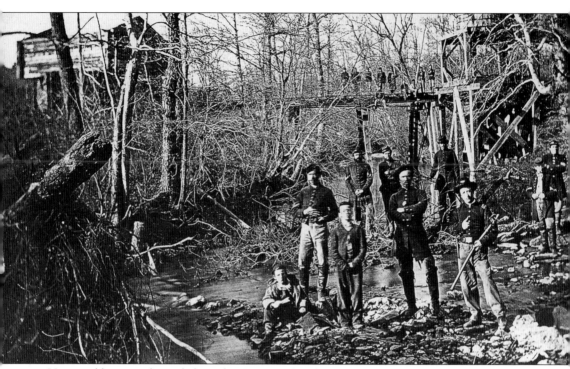

Union soldiers stand guard along the O&A Railroad at Sangster Station in 1863 with a partially constructed military blockhouse, railroad trestle, water tanks, and pumping station. (Courtesy National Archives; information courtesy Ron Beavers and Chuck Siegel.)

Three

THE BATTLE OF
SANGSTER STATION

This "Hot Little Fight" fought near Clifton on December 17, 1863, was so significant that in 1903, the Fairfax County Board of Supervisors received a letter from former participating Union captain John McAnally. The letter petitioned for a monument honoring soldiers killed and wounded where some 65 Union soldiers faced more than 700 Confederate cavalry. The "Tears and Love" monument was erected in 1904 near the Fairfax County Poor House, located by the O&A Railroad line near Sangster Station, outside the newly incorporated town of Clifton. The monument indicated the Confederates lost two soldiers from brigade commander Brig. Gen. Thomas Rosser's "Laurel" Brigade, Company B, 11th Virginia Calvary. Company I, 155th New York Infantry, was guarding more than 10 miles of railroad including Sangster Station, where McAnally was serving. Union regiments headquartered at Fairfax Courthouse were commanded by newly assigned Brig. Gen. Michael Corcoran, who, due to the coming holidays, brought his wife to the courthouse. Corcoran allowed his officers' wives to join them at the Fairfax County Poor House, including three Gilbert sisters from Buffalo, New York, who later claimed they were robbed of their jewelry by Confederate cavalrymen during the raid. On December 16, during a torrential rain, Rosser lost three men to drowning as he crossed the Rappahannock and Occoquan at Wolf Run Shoals to close in on Sangster Station. A drunken station telegrapher did not pass word to the Fairfax headquarters about the emerging battle, so information hit the headquarters over two hours later. Company I of the 155th New York suffered four wounded, nine captured, and eight who later died as prisoners of war. Their resistance was broken during a fierce fight, which ensued at 6:00 p.m. in blinding and freezing rain. Reports indicate Company I buried four Confederate cavalry there on December 18. Company member Mike Casey officiated. One soldier, David Van Meter, passed away that morning, having been found by the Gilbert sisters. Rosser and his troops escaped to the Shenandoah Valley.

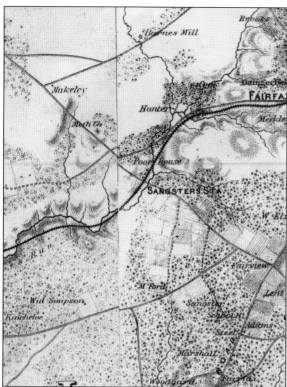

This 1860s map shows the Sangster Station battle area, indicating Fairfax County Poor House, the O&A Railroad line, bridges over Popes Head Creek, and local property owners. Sangster Station is clearly marked, as is nearby Union Mills. (Courtesy Ron Beavers and Chuck Siegel.)

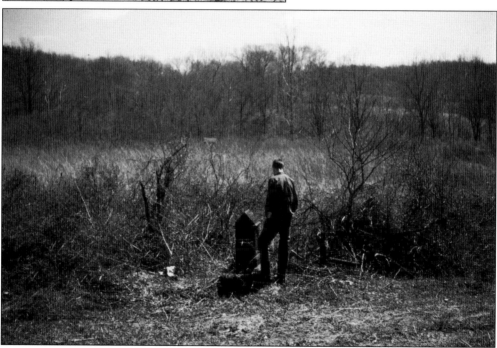

The "Tears and Love" monument erected near the Fairfax County Poor House in 1904 was located outside of Clifton and is shown in 1959 with the brother of local historian Lee Hubbard, Bob Hubbard. (Courtesy Lee Hubbard.)

Maj. Gen. Thomas Lafayette "Tex" Rosser (October 15, 1836–March 29, 1910) played a key role in the Battle of Sangster Station as well as in over 15 Civil War battles, including the First Battle of Manassas, the Second Battle of Bull Run, the Battle of Gettysburg, and the Appomattox Campaign. Appointed to the U.S. Military Academy in 1856 by Texas congressman Lemuel D. Evans, Rosser resigned two weeks before his graduation to support Texas's decision to secede, joining the Confederate States Army. His roommate at the academy was George Armstrong Custer, who Rosser faced in battle numerous times. Their friendship lasted before, during, and after the war. Following the war, he worked for a number of railroads, including the Northern Pacific. On June 10, 1898, Pres. William McKinley appointed him brigadier general of United States volunteers during the Spanish-American War. He ended his days as a gentleman farmer in Charlottesville, Virginia. (Courtesy David M. Goetz.)

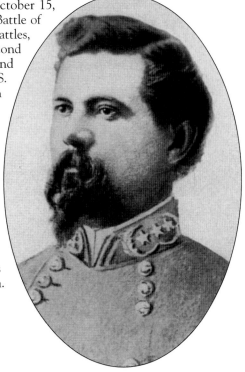

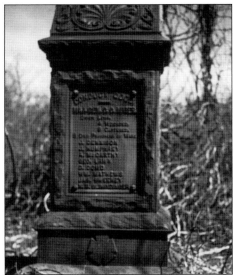 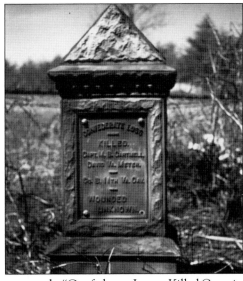

The front (left) side of the "Tears and Love" monument reads, "Confederate Loss—Killed Captain M. B. Cartwell and David Va. Meter, Co. B 11th VA Cav.—Wounded Unknown." The back (right) side of the monument reads, "Conduct Good—Maj. Gen. G. C. Auger, Union Loss, 4 Wounded, 9 Captured, 8 Died Prisoner of War: J. Dennison, J. Humphrey, A. McCarthy, Geo. Lawn, D. Dowd, Wm. Matthews, Jas. Sweeney, N. B. Slimindinger." These men served with Capt. John McAnally, Company I of the 155th New York Infantry at the December 17, 1863, Sangster Station battle. (Courtesy John McAnaw and Lee Hubbard.)

Buffalo, New York,

July Fourth, 1903 .

To the Honorable-

The Board of Supervisors-

Fairfax County - Virginia .

Gentlemen:

I respectfully ask permission from Your Honorable Board, to erect a small Monument on the grounds of the Alms House at Clifton, in Fairfax County.

Clifton was formerly known as Sangster's Station, and was so known, when my Company was engaged with General Thomas Rosser's Brigade of Cavalry, on December the 17th 1863 .

I beg to state in connection with my request, as above, that I have had some correspondence with Superintendent Ford, and if your Honorable Board could arrange a conference with Mr Ford regarding the subject matter herein, I am sure that he could furnish gladly some very valuable information. When I wrote to Superintendent Ford requesting information as to whom to apply for permission to erect the Monument, he informed me that he well remembered me, and refreshed my memory very pleasantly with some reminiscences that occurred during the time our camp was pitched at Sangster's Station, and referred me to Your Honorable Board for the necessary permission .

If I can succeed in my object, i.e., the obtainment of your very kind permission to erect this Monument, I will be highly honored, and will be glad to meet your Honorable Board at its Dedication. Also would I be especially

This letter from Capt. John McAnally, sent to the Fairfax County Board of Supervisors, was written on July 4, 1903, clearly an indication of McAnally's patriotism and commitment to a united cause following the Civil War. He was an elderly man at this time, nearly 40 years after the war ended, and this was surely his way to honor lives lost under his command in the War Between the States. (Courtesy John McAnaw and Lee Hubbard.)

honored, if I could meet at its Dedication, some of the members of the Brave and Gallant SEVENTEENTH VIRGINIA, with whom my Company had a sharp encounter at the siege of Suffolk on the morning of April 15th 1863. The members of the 17th Virginia were raised mostly in Fairfax County and I would esteem it a priceless privilege and great honor to greet them at the Dedicatory ceremonies .

Should Your Honorable Board grant my request, I will be pleased to submit for your approval, the details of the design and other information about the proposed Monument that your Honorable Board may desire .

I beg to subscribe myself-

Very Sincerely yours-

John McAnally

No. 437 Brockenridge Street,
Buffalo, New York.

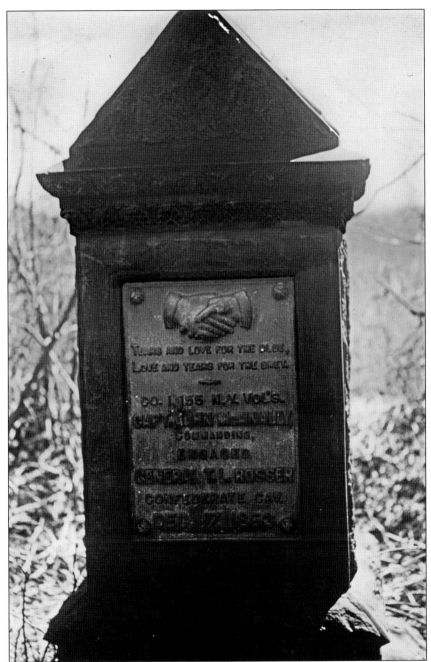

This side of the monument indicates peaceful reunification through the depiction of clasped, gloved hands and the words, "Tears and Love for the Blue, Love and Tears for the Grey. Co. I, 155 NY Vol's, Capt. John McAnally, Commanding, Engaged General T. L. Rosser Confederate Cav. December 17, 1863." The monument was placed on the grounds of the Fairfax County "Alms House" in 1904. Vandalism and partial destruction caused the monument to be taken down in the 1960s, with its pieces passed on to local historians for safekeeping. Pieces are currently with a local Fairfax historian who is remounting them for placement in the Fairfax Railroad Museum. (Courtesy John McAnaw and Lee Hubbard.)

This angle of the "Tears and Love" monument illustrates an intricacy of design in the metal scrollwork on the top and the carved stone below. The design was given considerable thought and was a beautiful memorial to the men whose lives were lost or shattered on December 17, 1863. On this side are the words "Hot Little Fight, Words of Lieut. J. H. Daughtery, Co., B, Va. Gen. Cav.—Their glory still lives while the years roll away." No intentional landscaping was done around the monument, and its lone presence in this large field seems rather lost. The designer and location of the monument's manufacture are unknown. (Courtesy John McAnaw and Lee Hubbard.)

Four

JOHN HENRY DEVEREUX

John H. Devereux wrote his superior on July 26, 1863:

General Herman Haupt,

No. 1 train this A.M. found, a mile and half east of Burkes, a rail taken out of the track and horseshoes on rail. Engine was reversed and brakes put hard down. . . . Had it been rail on opposite side, train would have run off track down a twelve-foot bank. Before train was checked, twelve rebels in grey and blue coats . . . all with guns pushed out of bushes whilst the guard of Fourth Delaware . . . jumped off train and had a foot-race through woods after the rebel . . . Providence saved a smash-which . . . would have prevented the Army of the Potomac from receiving supplies. It is pitiful that a handful of rebels can be allowed the chance of retarding the progress of our army. . . . I earnestly ask that 200 men be at once stationed from Accotink to Burkes.

Devereux Station (Clifton) received its name from a great 19th-century railroad figure. John Henry Devereux (1832–1886) inherited a strong work ethic from his father, John, a "driving energy and rigid discipline—tempered by an underlying kindness and respect for his subordinates." After studying engineering and graduating from his hometown Marblehead Academy, Massachusetts, in 1848, Devereux found employment as a civil engineer at Cleveland, Columbus, and Cincinnati Railroad. In 1851, he married Antoinette Kelsey. He worked with the Tennessee and Alabama Railroad and served as city engineer in Nashville. Devereux became a member of the Episcopalian church and Masonic Lodge. He is a descendant of Sir Walter Devereux, fifth Viscount of Hereford, ancestor to the famous Robert Devereux, Earl of Essex during the reign of Queen Elizabeth I. His stellar reputation brought him to Washington, D.C., to serve as civil engineer of federal railroads in 1862. Daniel C. McCallum, military director of railroads, asked him to direct all transportation matters at Alexandria, Virginia—a critical location in protecting the nation's capital during the Civil War and in supporting the Union army. Devereux reported to Hermann Haupt, who oversaw bridge building along the O&A. Devereux outfitted railroad cars with water, heating, and lighting, allowing for better care of the war's wounded. When Devereux returned to Cleveland, his career continued to soar, as he became president of Lake Shore; Cleveland, Columbus, Cincinnati, and Indianapolis; and Atlantic and Great Western Railroads. The Cleveland Daily Leader newspaper said, "His reputation was known wherever the iron horse traveled." During difficult industry times, Devereux found solace as warden of St. Paul's Episcopal Church. He helped build a monument at Lake View Cemetery for President Garfield, and a Great Lakes steamer was named J. H. Devereux. Devereux died of cancer on March 17, 1886. In deep mourning, great railroad lines passed grief resolutions. The Union Depot lowered its flag to half-mast. His remains were buried at Lake View Cemetery with many of Cleveland's great leaders: Samuel and Flora Mather, John L. and Elizabeth Severance, John D. Rockefeller, and Chester C. and Frances P. Bolton.

ORANGE & ALEXANDRIA LINE.

NOTICE TO PASSENGERS.

BY AUTHORITY OF THE GENERALS COMMANDING
The Army of the Potomac and the Department of Washington,

PASSENGERS

WILL NOT BE ALLOWED TRANSPORTATION

FROM

Alexandria, Brandy or Intermediate Stations,

EXCEPT ON THE FOLLOWING TRAINS, VIZ:

GOING WEST.			To take effect Monday, April 18, 1864.	GOING EAST.	
No. 7	No. 5		STATIONS.	No. 6.	No. 8.
Way Freight.	Passenger Train.			Passenger Train.	Way Freight.
A. M. 11.00	A. M. 10.50	LEAVE	ALEXANDRIA, ARRIVE	1.30 P. M.	5.05 P. M.
11.30	11.11	do.	EDSALL, LEAVE	1.15	4.45
11.38	11.21	do.	SPRINGFIELD, do.	1.10	4.40
P. M. 12.15	11.41	do.	BURKE, do.	12.50	4.15
12.35	11.55	do.	FAIRFAX, do.	12.31	2.55
12.55	P. M. 12.15	do.	DEVEREUX, do.	12.15	2.31
1.08	12.22	do.	UNION MILLS, do.	11.65	2.20
1.32	12.38	do.	MANASSAS, do.	11.33 A. M.	2.57
1.57	12.53	do.	BRETOE, do.	11.38	2.33
2.15	1.05	do.	NOKESVILLE, do.	11.25	2.15
2.47	1.23	do.	CATLETT, do.	11.08	1.42
3.00	1.30	do.	WARRENTON JUNCT'N, do.	11.00	1.30
3.50	2.00	do.	BEALETON, do.	10.25	12.40
4.15	2.28	do.	RAPPAHANNOCK, do.	9.55	12.15
4.34	2.47	do.	INGALLS, do.	9.35	11.57 A. M.
P. M. 4.45	3.00	ARRIVE	BRANDY, LEAVE	9.20	11.45

No. 5, Passenger Train, will leave Maryland Avenue Station, corner Eighth Street, Washington, at 9:45 A. M.
No. 6, Passenger Train, will arrive at Washington at 2:15 P. M.

A PASSENGER CAR, ASSIGNED EXCLUSIVELY TO OFFICERS, ACCOMPANIES EACH PASSENGER TRAIN.

SINGLE HORSES, belonging to Officers and accompanied by proper papers, will be carried on Trains Nos. 5 and 6, if presented for transportation thirty (30) minutes previous to the time of leaving.

M. J. McCRICHETT,
Assistant Superintendent O. & A. R. Rds., Alexandria.

E. L. WENTZ,
Chief Engineer & General Superintendent O. & A. R. Rds., Va.

APPROVED—
D. C. McCALLUM, Col. U. S. A.,
Director and General Manager Military Railroads U. S.

As Devereux carried out his duties, he was clear about the type of man to hire: "excluding those who drank too much, and the ones he suspected were unable to obey." He likewise refused to employ "men who could not control their temper." In keeping with the period custom of naming a new engine after a prominent Union military leader, his men honored him by naming a new locomotive after him. The *J. H. Devereux* proudly took its place alongside the *Haupt*, *General Hooker*, and *General Burnside*. The employees also named the sixth stop on the O&A Railroad, between Fairfax Station and Union Mills, "Devereux Station." The O&A Railroad schedule shows station stops, times, and type of train, freight or passenger, during 1864. Note Stop No. 6 is Devereux Station. (Courtesy Bill Etue and Ron Beavers.)

In 1871, Devereux commissioned a builder for the Devereux mansion on Cleveland's famed "Millionaire's Row," on Euclid Avenue. There the John D. Rockefeller, Samuel Mathers, and Charles F. Brush families shared a prime location with easy access into Cleveland, Ohio. He received a "sign-on" bonus in 1873 of $10,000 to work for the Cleveland, Columbus, Cincinnati, and Indianapolis (CCC&I) Railroad as chief executive officer with a yearly income of $20,000. Devereux's home was near Sterling Street, and he walked to the CCC&I offices each morning. (Author's collection; architectural drawings of Cleveland's famous mansions, Dale Gallis.)

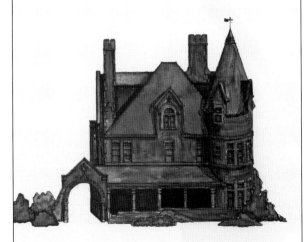

FRENCH — DEVEREUX

In 1890, architect Schweinfurth completed another handsome masterpiece on the Avenue. This achievement came through careful incorporation of the naturally beautiful texture found in the rock-faced ashlar. Simplicity unusual for the time, was maintained through use of solid geometric forms in the massive tower which was complemented by deep-set windows. In 1951, this stone mansion was torn down in order to accommodate the expansion of Cleveland State University.

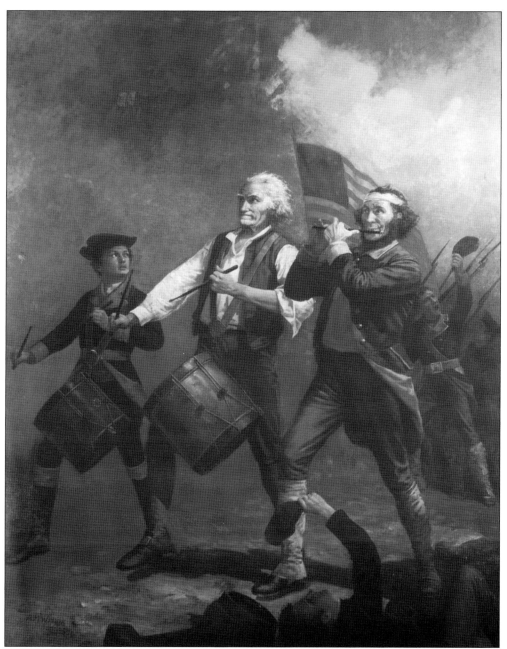

In 1876, Devereux's friend and well-known Cleveland artist Archibald MacNeal Willard painted *Spirit of '76* for the U.S. centennial. Willard's father was the model for the center figure, and young Henry Devereux was the model for the young drummer boy. Devereux and his wife, Nellie, had three children: John, who worked at CCC&I; Henry, who was fond of horse racing and cofounded the North Randall Race Track in Cleveland; and daughter Antoinette, called "Lady." (Courtesy U.S. Department of State.)

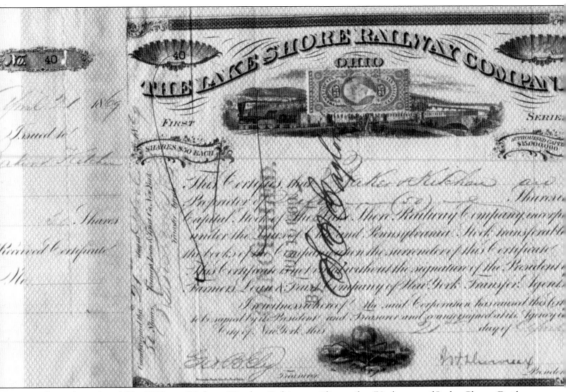

Issued on April 21, 1869, to "Bakers Kitchen" this certificate for 50 shares of Lake Shore Railway stock was worth $50 a share and hand signed by J. H. Devereux. Devereux was described by the *Cleveland Daily Leader*: "It . . . [was] needless to speak of Mr. Devereux as a railroad man . . . for his reputation as such was known wherever the iron horse traveled on the American continent. He was known as a scientific engineer, a most successful Superintendent and a courteous gentleman." A large, burly, 265-pound man, Devereux loved cigars and treated everyone he met with a great deal of warmth and affection. (Author's collection.)

GEN. DEVEREUX BURIED.

CLEVELAND, Ohio, March 20.—The funeral of the late Gen. Devereux took place at 2:30 o'clock this afternoon. Services were held in St. Paul's Episcopal Church, after which the remains were taken to Lake View Cemetery for interment. Among those present were Cornelius Vanderbilt, Chauncey M. Depew, J. M. Toucey, and Dr. W. S. Webb, of New-York. Ex-President Rutherford B. Hayes was an honorary pall bearer.

Pictured here is the obituary for John Devereux in 1886. (Courtesy New York Times Historical Newspapers.)

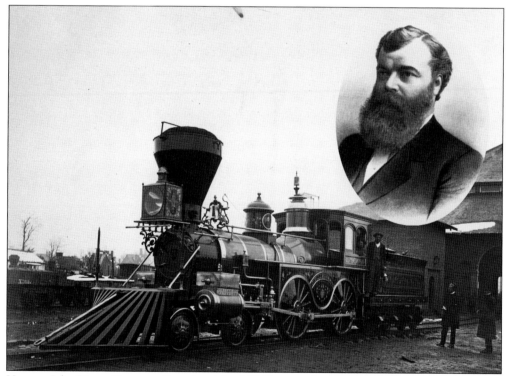

Here are John Henry Devereux (inset) and the *J. H. Devereux* locomotive. Hailing from Marblehead, Massachusetts, Devereux inherited his father's strong shipmaster's work ethic, described as full of "driving energy and rigid discipline—tempered by an underlying kindness and respect for his subordinates." Such a work ethic resulted in Stop No. 6 being named for him on the O&A Railroad. (Courtesy Library of Congress and Patrick O'Neill.)

The town of Clifton state historical marker for the Devereux Station, later known as Clifton Station, is pictured here. (Courtesy Ed Parker.)

Five

CLIFTON AND AMERICA'S PROGRESSIVE ERA

America's Progressive Era (1890–1920) involved citizens seeking social justice, general equality, and public safety. Three Progressive institutions were located near Clifton: Ivakota Farm, Lorton Reformatory, and Occoquan Workhouse. Dr. Kate Waller Barrett directed the National Florence Crittenden Mission's (NFCM) Ivakota Farm (named for states Iowa, Virginia, and North Dakota, where owner/donor Ella Shaw had lived), known as "The House of Another Chance." NFCM received 264 acres after Shaw read Dr. Barrett's 1913 *Washington Times* articles describing the plight of unwed pregnant girls. The myth that a cure for male syphilis was to bed a female virgin resulted in so many diseased pregnancies, Congress formally chartered the NFCM in 1893. Highly acclaimed Ivakota was a refuge for such women. Operating from 1917 to 1958, Ivakota provided thousands of women the benefit of a rural environment with spiritual, physical, vocational, and domestic education. The Fairfax County History Commission placed a historic marker there in 2007.

In 1908, President Roosevelt investigated deplorable conditions at the District of Columbia's jail/workhouse. In 1910, the purchase of 1,155 acres north of the Occoquan River allowed construction of a reformatory, Lorton. Dormitory living on an open-air campus provided 400 prisoners with spiritual and vocational education while providing labor for the farm and on-site foundry, where D.C. manhole covers/fire hydrants were manufactured. Brick-making and animal husbandry were taught. Lorton Prison closed in 1998. In 2005, Lorton/Laurel Hill received a National Register nomination and currently houses an arts foundation, high school, parkland, economic housing, and golf course. After 72 years of struggle, the suffrage movement saw success in August 1920, when women won the right to vote. In 1917, an outraged public saw over 123 women peacefully demonstrating in front of the White House taken to the Occoquan Workhouse and tortured. Today a Virginia state marker honors the site where these courageous women fought so all American women can vote.

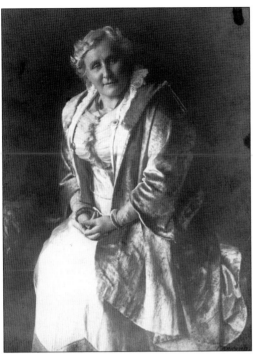

Photographed here in 1905, Dr. Kate Waller Barrett (1857–1925) was a great American Progressive Era reformer. President of the NFCM, the American Legion Auxiliary, Daughters of the American Revolution, and National Council of Women, she was also a delegate to the National Peace Conference at Zurich, Switzerland, in 1919. Involved in early suffragist efforts, she helped found the League of Women Voters in 1920. (Courtesy Jack Smith and Barrett families.)

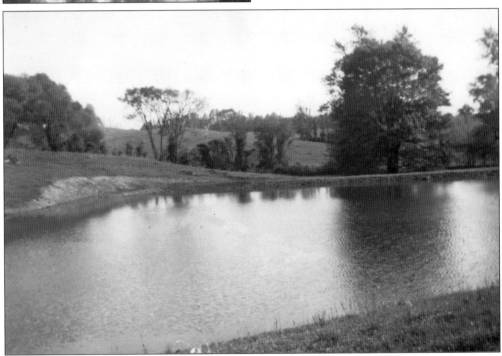

The 264 acres of farmland donated by Ella Shaw to the NFCM, shown in the 1950s, became a successful bucolic refuge for the women who lived at Ivakota Farm. Their tenure was anywhere from six months to three years, depending on the type of assistance required. Given spiritual, educational, and vocational guidance, they were taught to put their "Heart in Hand" as they completed their work. (Courtesy Jack Smith and Barrett families.)

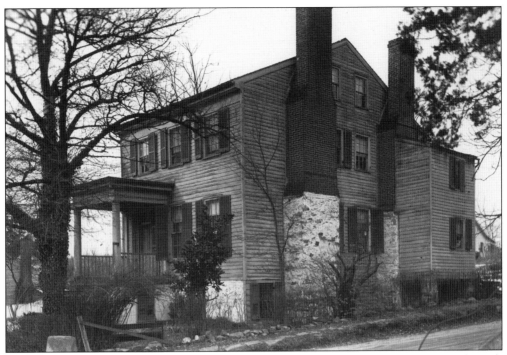

The childhood home of Dr. Barrett, pictured around 1939, was ironically called Clifton, at Falmouth and was located in Stafford, Virginia. At age 19, she married Rev. Robert South Barrett in 1876. Her six sisters served as attendants. She is buried at the Old Aquia (Episcopal) Churchyard in Stafford. (Courtesy Ruth Rose.)

family. Here a child is given all the help and joy, impossible to be obtained except under these constructive conditions.

GROUP NUMBER THREE. The D. A. R. Victory School is a model school building, erected through the help and under the direction of the D. A. R. of Va. Here is a community centre, commodious school-rooms, and a large assembly hall. A circulating library, lectures and moving pictures of educational value, and general welfare neighborhood work has been planned. This is the neighborhood school in the mornings, and in the afternoons, under the best instructors, the Ivakota girls get their education in the various public school studies.

GROUP NUMBER FOUR. A modern dormitory, assembly room, class room, laundry, with sleeping accommodations for 50 girls.

WHY SHOULD I BE ASKED TO SUPPORT IVAKOTA?

FIRST: Because it is a HUNDRED PER CENT. AMERICAN Institution in its ideals, purposes and organization. Conducted on democratic lines of self-government, where each has a right to the "pursuit of life, liberty and happiness."

It is a new and humane departure in reformatory measures. In Group Number One, although the girls are committed by the courts, no bolts or bars are needed. A free, normal life, with earning capacity of a living wage in some useful and congenial employment, fits girls to be restored to society.

RESULTS: Although more than nine hundred girls have been cared for to date, only three have broken their probation.

SECOND: Because nowhere else can your funds bring in more return for every dollar invested in this interesting work of reconstructing broken lives. Ivakota has many points of contact with remedial agencies, both National and State, and through these, municipalities and counties can get the best care for their delinquents and dependent children.

THIRD: Because it saves thousands of dollars to the tax payers. At the average cost of caring for delinquents in public institutions at least $125,000.00 has been saved the State of Virginia by Ivakota,—to say nothing of the rehabilitation of the State's greatest assets, its boys and girls.

FOURTH: Because, *and most important of all,* broken humanity should be placed in a repair shop and not on the dump pile.

WHO IS ELIGIBLE? As far as possible all red tape has been eliminated and to its full capacity, Ivakota receives every homeless or needy child with its mother, or any friendless or delinquent girl. They may be committed by the Courts, or placed there by family or friends, or even come of their own accord. Only in cases committed by the Courts is the date of sentence fixed, and then probation may reduce the time. Girls are expected to remain, if they obey the rules and show normal progress, until they are placed in suitable positions.

HOW IS IVAKOTA SUPPORTED?

Both the farm and Roanoke Cottage were gifts. Virginia allows sixty cents per day for each girl committed by the Courts. This is the price allowed to Sheriffs for the feeding of prisoners. For it Ivakota, in addition to food, furnishes lodging, education, clothes, medical attention and training. Interested friends, the generous public contribute the remainder. The expenses are far below ordinary institutions. Farm products and the labor of girls going very far to reduce the expenses.

HOW IS IVAKOTA GOVERNED?

It is conducted under a charter granted by the State and it has a Board of Directors, all of whom serve without compensation. In its beginning the deficit was met by the National Florence Crittenton Mission, who see in the development of the farm colony a realization of the ideal in the mind of Mr. Chas. N. Crittenton, whose practical ideas led to the establishment of the Florence Crittenton Homes, which is still the model of successful institutions for caring for girls.

The Board of Charities of Virginia has supervision of the State Cases and the Clinic is conducted under the Public Health Service.

An Ivakota Farm brochure published in 1924 describes the setup and governance of the farm; it was shared with prospective donors who contributed to the $40,370.76 in revenue for 1924. Donations made up over $10,000 of the farm income. (Courtesy Jack Smith and Barrett families.)

The Ivakota Farm Main House, shown in 1937, sat on a campus described by Dr. Barrett to future Ivakota Farm residents as looking like a "millionaire's estate." This building, according to Stewart Buckley, raised on the property, had the columns added to resemble a regal residence. The main building housed a formal dining room. The grounds were kept in meticulous condition with the girls assisting. They were treated with great care, respect, and dignity. Dr. Barrett taught them, "Keep your head to the Sunshine and the Shadows will fall behind." (Courtesy Jack Smith and Barrett families.)

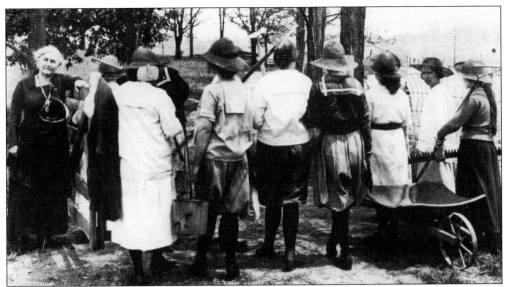

Dr. Barrett took personal interest in the girls at Ivakota Farm, located near her home and headquarters of the NFCM at 408 Duke Street in Alexandria. Shown with Ivakota girls in 1923, she encouraged them to keep their anonymity in front of a camera, to protect themselves and their children from possible future public ridicule. (Courtesy Jack Smith and Barrett families.)

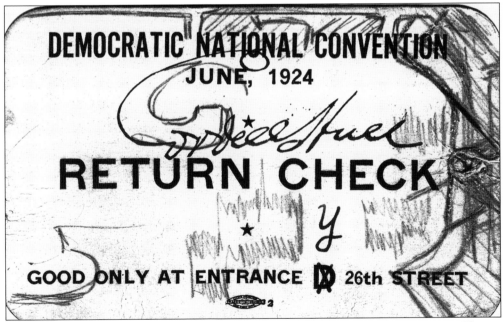

Dr. Barrett received a standing ovation for her "Seconding speech" to nominate Carter Glass as vice presidential candidate at the Democratic National Convention in New York in 1924. Her speech encouraged an "alliance between Main Street and Wall Street," resulting in her being asked to run for governorship of Virginia and as the vice presidential candidate! (Courtesy Jack Smith and Barrett families.)

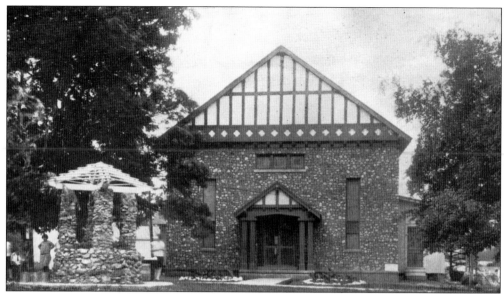

Kate Waller Barrett Chapel (built 1927) is pictured after her death in 1925. The dedication stone on the right side of the building was discovered in 2007, weeks before the Ivakota Farm historic marker dedication. A Clifton "Balmoral Greens" neighbor indicated she had a portion of the stone. Dr. Barrett hailed from Spotsylvania County, and the stone now sits in their history museum. (Courtesy Jack Smith and Barrett families.)

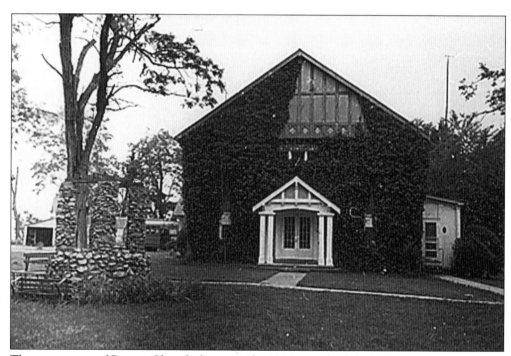

The stone tower of Barrett Chapel, shown in the 1940s, was built by Ivakota Farm girls as part of the masonry skills they were taught. The ivy has covered the dedication stone seen in the previous picture. (Courtesy Jack Smith and Barrett families.)

By 1962, due to use of antibiotics to treat venereal disease, changes in social norms, and the use of the birth control pill, the need for a facility such as Ivakota Farm diminished significantly. Shown is the abandoned Barrett Chapel. The Balmoral Greens subdivision in Clifton currently sits on the site. (Courtesy Virginia Room, Fairfax City Library.)

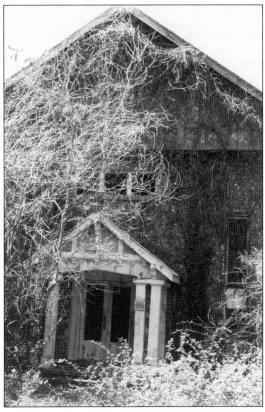

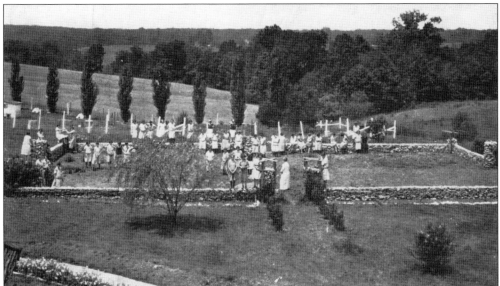

Producing over 52,000 pieces of clothing, 15,000 cans of vegetables, and 3,000 cans of pickles and gathering/canning 580 quarts of berries annually, Ivakota earned the revenue to pay for one third of its expenses. Their slogan was, "I am an American Girl and I am going to make the world know I am worth something." Here the Rose Garden is under construction in 1928. (Courtesy Jack Smith and Barrett families.)

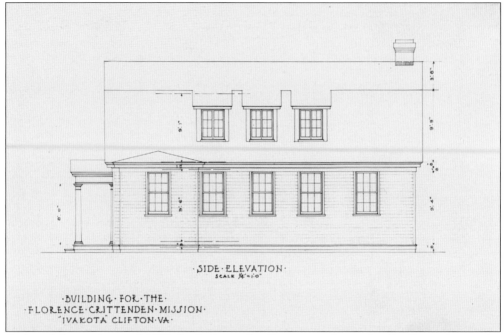

·SIDE·ELEVATION·
SCALE ¼"=1'·0"

·BUILDING·FOR·THE·
·FLORENCE·CRITTENDEN·MISSION·
"IVAKOTA" CLIFTON·VA·

Built and designed around 1925, the Ivakota schoolhouse was donated in Dr. Barrett's name by the Daughters of the American Revolution. A four-room schoolhouse with an auditorium on the second floor, the on-campus school replaced the nearby Crouch school, providing education for Clifton children. The property, purchased in 1962 by a local family, has been renovated as a private residence. (Courtesy Library of Congress.)

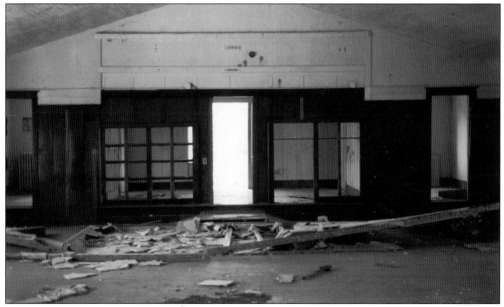

The abandoned second-floor auditorium of the Ivakota schoolhouse is seen here during renovation for a private home in 1962. The auditorium was used for sports events, school assemblies, and local 4-H agents demonstrating proper ways to store, prepare, and cook a variety of food produce. (Courtesy Virginia Room, Fairfax City Library.)

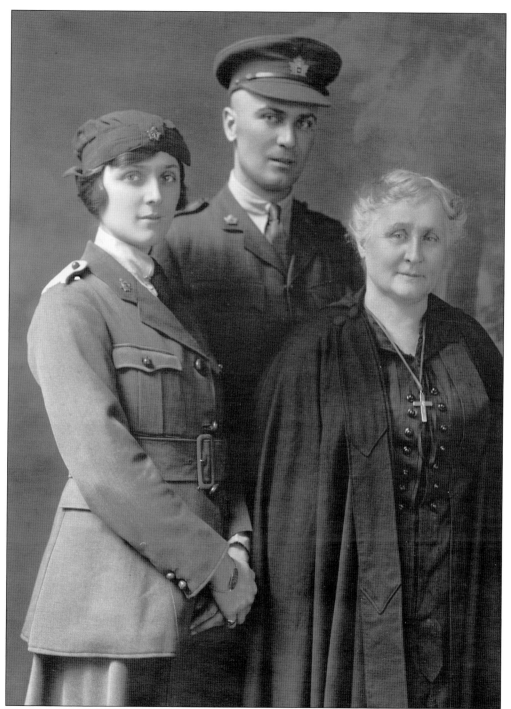

Kitty Barrett Pozer, one of Dr. Barrett's six children, is pictured with her husband, Charlie, and mother. Charlie served in the Canadian Air Force during World War I, and Kitty was an ambulance driver. She became a gardener and columnist; her beautiful gardens at the Ratcliffe-Allison House museum draw crowds during the summer. They were the sale location of Ivakota Farm's produce. (Courtesy Jack Smith and Barrett families.)

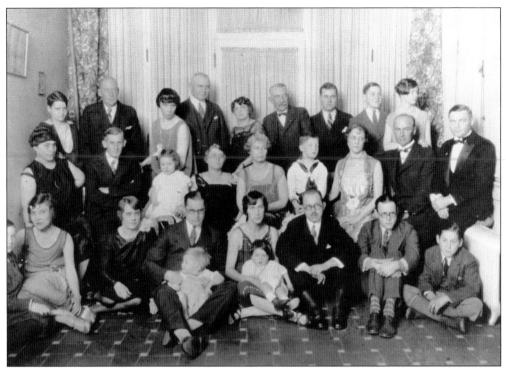

Christmas in 1922 was celebrated at Dr. Barrett's home in Alexandria. From left to right are (first row) Douglas and Reba Smith; Cornelia Barrett, Waller Barrett, Waller Barrett Jr., Marie Barrett, Treppe Barrett, "Daddy" and Billy Smith; (second row) B. B. Barrett, Jack Barrett; Emily Barrett, "Grand Mama" Kate Barrett, Lila Alfriend; Charlie Barrett; Kitty Barrett and Charlie Pozer; and Col. Charlie Barrett; (third row) Viola Barrett; Rathbone Smith; Emily Barrett, Robert Barrett; Aunt Violie; John Barrett, Pahlo Barrett, Waller Smith, and "Sister" Smith. (Courtesy Jack Smith.)

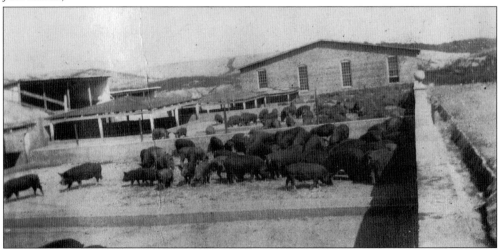

Lorton Reformatory provided a self-sufficient environment for its inmates and vocational training in a variety of disciplines. On-site were a hog ranch (shown around 1941), a poultry farm, slaughterhouse, dairy, blacksmith shop, sawmill, foundry, and an extensive orchard. Lorton was located near the Occoquan River and Workhouse. (Courtesy Lee Hubbard.)

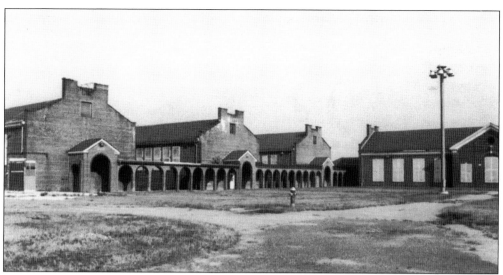

The Lorton Reformatory and Workhouse are pictured around 1980. Note the open-air design of the campus and the brick construction. The bricks were made on-site in two kilns and the buildings were constructed by the prisoners. The original Progressive Era philosophy of fresh air, education, and physical exercise made the early days of the reformatory a successful environment for reforming some 400 prisoners. (Courtesy Virginia Department of Historic Resources.)

Occoquan Workhouse, shown around 1917, was the destination for some 123 women who, in 1917, stood daily in front of the White House protesting for the right to vote. After six months of peaceful picketing, the protesting became an embarrassment to Pres. Woodrow Wilson's administration. The women had been quietly standing seven days a week with hand-stitched banners declaring, "How long must women wait for liberty?" By June, six women were tried and found guilty on the charge of obstructing traffic and were warned of their "unpatriotic, almost treasonable behavior." Arrests began in July of that year and continued until November. (Courtesy Bernice Colvard, Sherry Zachary, and the League of Women Voters.)

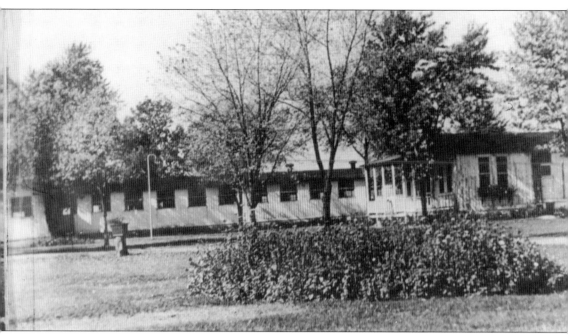

This Occoquan Workhouse side view is from 1917. Once brought to the Occoquan Workhouse, the protestors were tortured, stripped, beaten, starved, and then force-fed. One prison matron lost her job after being caught trying to be nice to several of the suffragists. They were forced to perform prison work and sew undergarments for the male prisoners. The abusive treatment became national news and facilitated passage of the United States' 19th Amendment in 1920. (Courtesy Bernice Colvard, Sherry Zachary, and the League of Women Voters.)

Six

THE CHURCHES
OF CLIFTON

The Clifton Presbyterian Church (founded in 1870), the Primitive Baptist Church (built in 1871), the Clifton Baptist Church (dedicated in 1875), and the Clifton Mission (Episcopal) Church (founded in 1906) all made Chapel Road the logical name for the easy-access route into Clifton. Clifton Presbyterian Church was built by 1872. Harrison G. Otis purchased land from the Harris family (freed slaves who had been part of the Beckwith plantation) on which he built the Clifton Hotel. Otis stated the back piece of the property "into perpetuity is to be a Presbyterian Church." The church met initially at Clifton's Hetzel home. Managing through changes in member growth, the church is a robust presence in Clifton today. Clifton's Primitive Baptist Church, Fairfax County's first African American church, was built by freed slaves of William Beckwith. Its exterior and interior appearance have changed little since 1871. Part of the Cub Run Baptist Church community, it is used today for weddings and town meetings. The last official Sunday service was held in 1957. The Clifton Baptist Church burned and was rebuilt in 1910. Initially services were held at George W. Tillet's home; Tillet's son John served in the Civil War in the 43rd Battalion, Virginia Cavalry, under Mosby. He attended the 1905 Reunion of the Cavalry in Fredericksburg. During the early 1900s, evening church services were held. Excellent relationships existed between the Presbyterian and Baptist churches. On July 1, 1921, the *Fairfax Herald* noted both churches' "Sunday schools . . . have united for the moral betterment of the town and have appointed a 'Temperance and Welfare Committee' . . . to aid in the enforcement of the prohibition and anti-gambling laws." The Clifton Mission Chapel (1906–1921) was the fourth Clifton church. A record in the Diocese of Virginia of 1907 states, "By . . . zealous self-sacrifice of Rev. John McNabb, a church building has been secured. . . . The Chapel can seat 200 people and is valued at $137.00." All churches are currently dedicated participants in the annual Historic Clifton Candlelight Tour, held the first Saturday in December.

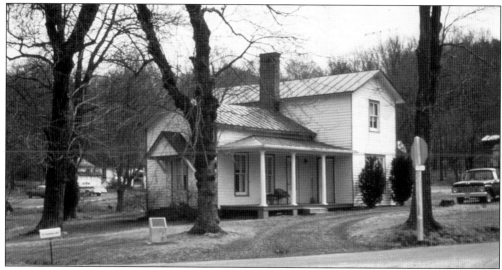

Schools and churches marked Clifton as a town of progressive thinking and righteous living. The Clifton Presbyterian Church met here by 1869, in the home of Margaret (mother) and Susan Reviere Hetzel (daughter), at the corner of Chapel Road and Pendleton Avenue. Both women were founding members of the Daughters of the American Revolution. They also provided the only schooling for local children for several years. Margaret Hetzel enjoyed farming and, in 1893, grew six varieties of pears and one of peaches. (Courtesy Virginia Room, Fairfax City Library.)

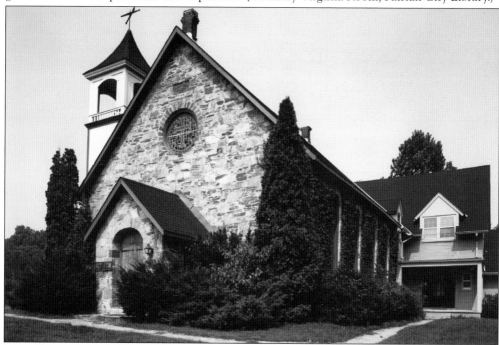

Clifton Presbyterian Church's original structure, shown in 1968, dates to 1872, with the initial rough-hewn cornerstone laid on December 30, 1870. The church was built from local rocks and stones—similar to those used on many bridges in the area. The main church building has changed little over 125 years. A large education addition was dedicated in January 2007. (Courtesy Virginia Room, Fairfax City Library.)

The indenture document establishes the Clifton Presbyterian Church as a member of the Synod of Baltimore and Presbytery of Washington City on June 30, 1873. The Synod granted $300 to aid the building of the church. Trustees included J. S. Otis (brother to Harrison), William Green, C. T. Newman, and William E. Ford. (Courtesy Clifton Presbyterian Church, Marla Hembree, historian.)

The Clifton Presbyterian Church Book of Record indicates founding member names including Otis, Newman, and Tillet on May 8, 1871. The first pastor was Rev. William Bradley from New Jersey with eight following pastors. Rev. William H. Edwards, who with his wife was well liked, stayed in Clifton for nearly 20 years. (Courtesy Clifton Presbyterian Church, Marla Hembree, historian.)

This Indenture made this twentieth day of December one thousand eight hundred & seventy two between Harrison G. Otis & Mary A. Otis his wife, of the one part, both of Ontario County state of ~~Virginia~~ New York, & H. G. Otis, J. Sandford Otis, N. P. Nodine, Charles T. Newman, Wm. E. Ford and William Green Trustees of Clifton Presbyterian Church in Fairfax County Virginia of the second part, Witnesseth; That in consideration of the premises, & of the sum of Five dollars, (the receipt of which is hereby acknowledged,) that the said parties of the first part, do grant, bargain, & sell, unto the afore mentied Trustees of the Clifton Presbyterian Church, parties of the second part — the lot or parcel of land situate & being in the village of Clifton in Fairfax County Va. & described as follows: Beginning at a point, or corner stone, forty feet north of the lands of the Orange, Alexandria & Manassas Rail Road, & eighty feet north

of the centre of the said Rail Road, and fifty feet east of the house near the spring owned by H. A. Otis, & running thence northerly on a line fifty feet east of the last named house to a point on the south side of a street, or road near the base of the hill on which the Church stands; & twenty five feet south of the centre thereof, & thence easterly, on a line twenty five feet south of the centre of the above mentioned street, or road, one hundred feet; thence southerly to a point one hundred fifty feet east of the house near the spring owned by H. A. Otis & eighty feet north of the centre of the said Orange, Alexandria and Manassas Rail Road. Thence westerly eighty feet from the centre of the said Rail Road, one hundred feet to the place of beginning, & known as the church Lot to be forever occupied as a site for a Presbyterian Church, to revert to the said Harrison G. Otis & Mary A. Otis, & their heirs, or assigns if not so used, without their consent. To the afore mentioned named Trustees of the Clifton Presbyterian Church in Fairfax County Va. & their successors in office forever. And the said Harrison G. Otis & Mary A. Otis his wife covenant with the afore named Trustees of the Clifton Presbyterian Church of Fairfax County Va. & their successors in office, that they will warrant generally the property hereby conveyed, & that they have the right to convey the same to the grantees, & that the grantees shall have quiet possession thereof free from all incumbrances as aforesaid. Witness our signatures & seals, this 8th day of January A. D. 1873.

Harrison G. Otis {Seal}
Mary A. Otis {Seal}

Witnessed by, H. L. Hicks
R. Simmons

The deed of trust establishing Clifton Presbyterian Church was signed by Harrison G. and Mary A. Otis on June 30, 1873. The $5 payment is for the purchase of the Otis property extending to the Orange, Alexandria, and Manassas Railroad line, stating, "The church Lot to be forever occupied as a site for a Presbyterian Church, & to revert to the said Harrison G. Otis & Mary A. Otis & their heirs, or assigns if not so used without their consent." (Both courtesy Clifton Presbyterian Church, Marla Hembree, historian.)

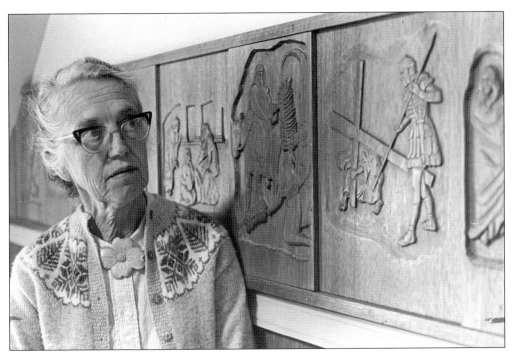

At Clifton Presbyterian Church, Margaret Webb views the wood panels depicting the story of Christ and carved in 1965 by her husband, Gen. Willard Webb. Others were installed in 2006, depicting women in the Scriptures, Noah's Ark, courage in the Scriptures, different styles of crosses, and the Beatitudes, and, from the New Testament, the Sermon on the Mount. (Courtesy Clifton Presbyterian Church, Marla Hembree, historian.)

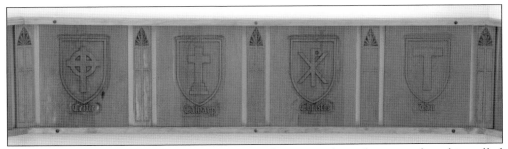

This panel depicts different Christian crosses; they were cleaned, mounted, and installed by Marla Hembree for the January 2007 Clifton Presbyterian Church Education Wing and Sanctuary Renovation Dedication ceremony. (Courtesy Clifton Presbyterian Church, Marla Hembree, historian.)

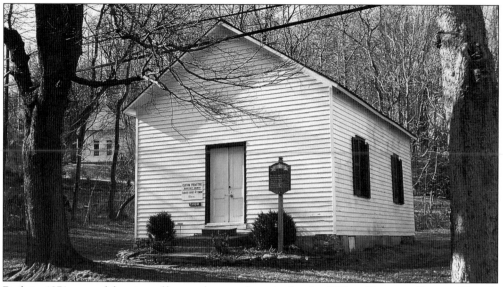

Built in 1871 as a celebration of hope, glory, and gratitude, the Clifton Primitive Baptist Church was constructed by the 16 freed slaves of William Beckwith. In the 1897 deed, a quarter-acre property was donated to the Clifton Old School Baptist Church by former slave owners Beckwith, Harris, and Moore. The Primitive Baptist, a sect of Baptism, enjoyed a large following between 1846 and 1890 and believed in worshipping and serving God in the simplest, most biblically correct manner possible. (Courtesy Susan Hellman, Fairfax County.)

Clifton Primitive Baptist Church is decorated for a spring wedding. Numerous brides and grooms have chosen this location for their nuptials. In keeping with the Primitive Baptist Sect, the interior is sparsely furnished with extremely simple appointments. Electricity and lighting were added within the past 20 years. The church was the first African American church in Fairfax County, now maintained by the Cub Run Baptist Church and Clifton Betterment Association. During a 1991 renovation, horsehair insulation was found in the walls as well as an old bathtub that was used for baptisms. (Author's collection.)

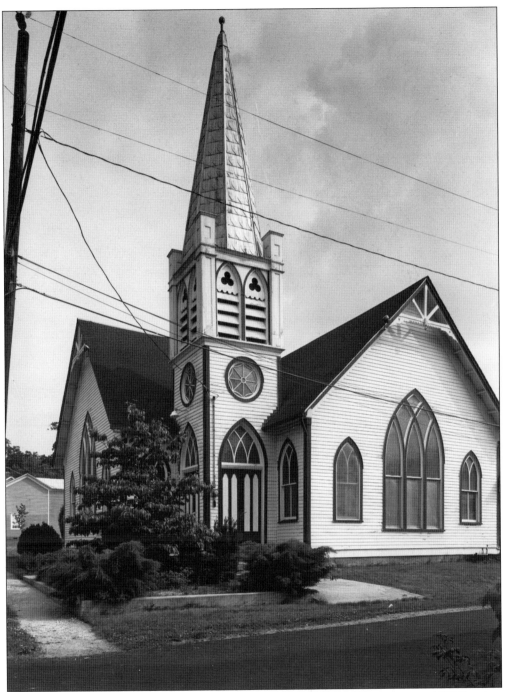

The Clifton Baptist Church was admitted into the Potomac Baptist Association in 1875. Services were first held in the home of George W. Tillet, who with his sons John, Henry, and George (John served in the 43rd Battalion, Virginia Cavalry, under Mosby) attended the 1905 Reunion of the Cavalry in Fredericksburg. George served in the Confederacy and is buried in the Manassas City Cemetery. The church's first building was a one-room building constructed in 1877. (Courtesy Virginia Room, Fairfax City Library.)

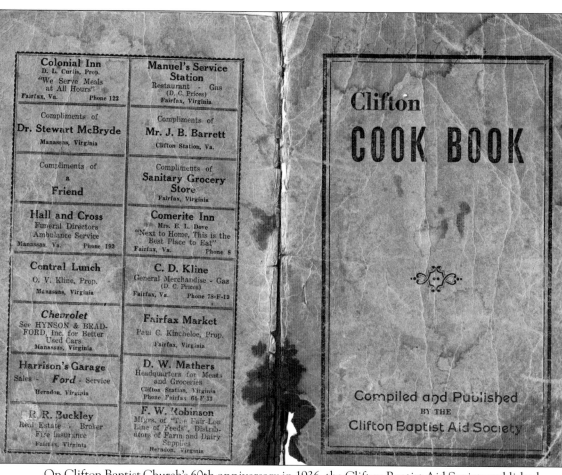

On Clifton Baptist Church's 60th anniversary in 1936, the Clifton Baptist Aid Society published a cookbook. This copy belonged to local Fairfax historian Lee Hubbard's grandmother, Mary "Nannie" Keys Taylor. The condition is a testimony to its frequency of use. The back named local businesses. Note the simplicity of phone numbers and types of businesses existing in 1936. The cookbook contained an unusual abbreviation: "p'c'k'g" for "package." "Packaged" products were not in the offering at the local general store! (Courtesy Lee Hubbard.)

A committee with familiar Clifton names—Buckley, Woodyard, Kincheloe, Mathers, Adair, Ford, and Mock—was required to coordinate the cookbook publication. The church looks almost as it does today; however, notice the rough street edge as it meets the small churchyard grass. Muddy and washed-out streets and highways were frequently a problem in the Clifton area before the Virginia Department of Transportation provided paved streets. Numerous articles in the *Fairfax Herald* attest to the comfortable relationship Clifton Baptist Church had with the Clifton Presbyterian Church. In 1901, the newspaper stated, "The kindest brotherly friendship and harmony exists between these two sister churches and Sunday schools." Clifton Baptist Church was the location of the final high school graduation commencement exercise in 1935. (Courtesy Rev. Carl Staats.)

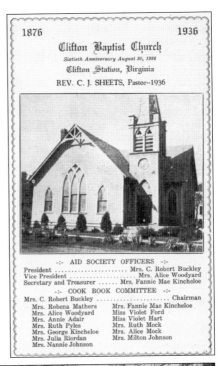

1876 1936

Clifton Baptist Church

Sixtieth Anniversary August 30, 1936

Clifton Station, Virginia

REV. C. J. SHEETS, Pastor—1936

-:- AID SOCIETY OFFICERS -:-

President Mrs. C. Robert Buckley
Vice President Mrs. Alice Woodyard
Secretary and Treasurer Mrs. Fannie Mae Kincheloe

-:- COOK BOOK COMMITTEE -:-

Mrs. C. Robert Buckley Chairman

Mrs. Robena Mathers	Mrs. Fannie Mae Kincheloe
Mrs. Alice Woodyard	Miss Violet Ford
Mrs. Annie Adair	Miss Violet Hart
Mrs. Ruth Pyles	Mrs. Ruth Mock
Mrs. George Kincheloe	Mrs. Alice Mock
Mrs. Julia Riordan	Mrs. Milton Johnson
Mrs. Nannie Johnson	

The Clifton Mission Church, "St. Francis Chapel," existed from 1906 to 1921, the fourth church in Clifton. The Episcopalian church enjoyed the preaching of the Right Reverend Robert A. Gibson, bishop of Virginia, in October 1906. In 1907, the Diocese of Virginia recorded, "By the energy and zealous self-sacrifice of the Rev. John McNabb, a church building has been secured for the congregation at this place. The furniture now in use is very neat and serviceable and has been put in by the joint efforts of the congregation and the rector." The chapel seated 200 people and was constructed of wood valued at $137 with a remaining debt of $137, according to church records. The December 13, 1907, *Fairfax Herald* noted, "The ladies of the Episcopal Church will have an oyster supper next Friday night, December 18th. All are cordially invited. . . . There will be preaching in the Episcopal Chapel next Sunday December 15th, at 11 a.m." (Courtesy Virginia Room, Fairfax City Library and Virginia Theological Seminary.)

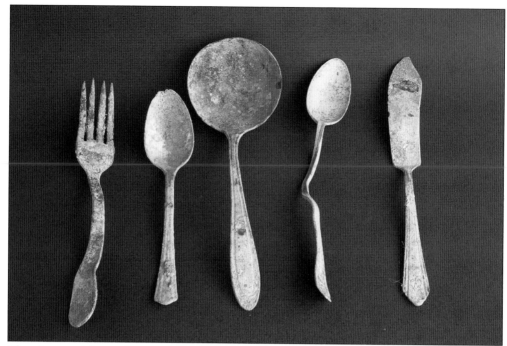

The above articles, with a man's pocket watch, ink bottle, porcelain shards, and cosmetic box, were found behind the Clifton Mission Chapel during renovations. Large boulders were also found, indicating another building foundation. The silverware may have been used during the church period when it played host to the oyster suppers earlier referenced. Also found was an early American Old Spice mug, used when the building housed the Clifton barbershop. (Courtesy Ed Parker.)

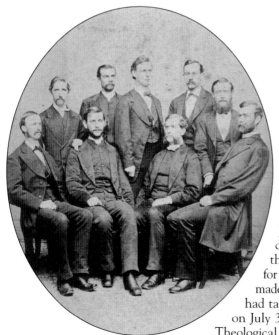

Rev. John McNabb, the first pastor of the Clifton Mission Chapel, is with his Virginia Theological Seminary class in 1876. Shown are (seated) John J. Gravatt, John K. Mason, Charles Morris, and Albert Ware; (standing) "Ranger" Frank Stringfellow, John McNabb, W. Strother Jones, C. C. Randolph, and G. P. Perry. The diocese recorded, "The lot is a good one and the building/adapted quite well to the purpose for which it is used, and the latter can easily be made in an attractive chapel." Reverend McNabb had taken official charge of Upper Truro Parish on July 3, 1899. (Courtesy Julia Randle, Virginia Theological Seminary Library Archives.)

Seven

THE SCHOOLS
OF CLIFTON

The first Clifton school was in the home of Margaret and Susan Reviere Hetzel in 1869. After 1871, a one-room schoolhouse was built on Castle Branch Road (Newman Road); however, the trek across the flood plain and railroad tracks made it difficult for children to attend. The Crouch family then provided classes in nearby Union Mill, operating from 1874 to 1930, at which point children attended Ivakota Farm's school. By 1890, the one-room schoolhouse became too small for all the Clifton students, and a two-story elementary and high school was built on Main Street across from where a new high school had been built in 1895. The combined school became home to two of Clifton's future mayors, W. Swem Elgin and Jim Chesley. The high school boasted an impressive, beautiful bell tower, spacious rooms, blackboards, and raised teacher platforms. In 1912, it was given to the Odd Fellows organization for their meetings. In spite of Clifton's fine academic offerings, some area parents were not diligent in encouraging their boys to attend class, and the February 18, 1910, *Fairfax Herald* noted lack of attendance in school was causing missed opportunities: "The mill can not grind with the water that is past." An appropriate statement, as Clifton had several thriving lumber and gristmills on Popes Head Creek. A new school was built high atop a hill above Clifton in 1912, with a 100-person capacity auditorium, a library, and six classrooms. One hundred forty students attended when it opened with the last Clifton High School graduation on June 6, 1935. Clifton high school students later attended Fairfax and eventually Robinson High Schools. In 1953, the 1912 school was razed and a new, modern elementary school was built, which still serves the Clifton elementary schoolchildren and the voting poll.

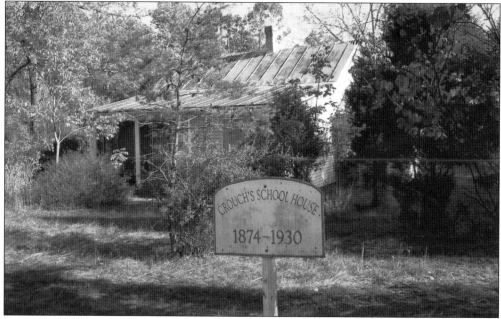

Students attended the Crouch School from 1874 until 1930, then the Ivakota Farm School. Harry and Nena Crouch, longtime Clifton residents and descendants of earlier settlers, moved into the old school. Lester Crouch was a police sergeant and Clifton resident. The Crouches supported Ivakota Farm when they started serving the Crouch School's students. Harry is remembered as an individual with a multitude of collections and an excellent "oral history" source. A number of area schools and mercantiles also became homes. (Author's collection.)

Clifton's 1895 high school, Fairfax County's first high school, is shown here in the late 1960s. Serving the area until 1912, the building was demolished in 1978 after many failed fund-raising attempts. (Courtesy Virginia Room, Fairfax City Library.)

The beautiful and ornate bell tower of the Clifton High School, shown in the 1960s, was built in 1895. Used as a school until 1912, it then became the Odd Fellows Hall. (Courtesy Virginia Room, Fairfax City Library.)

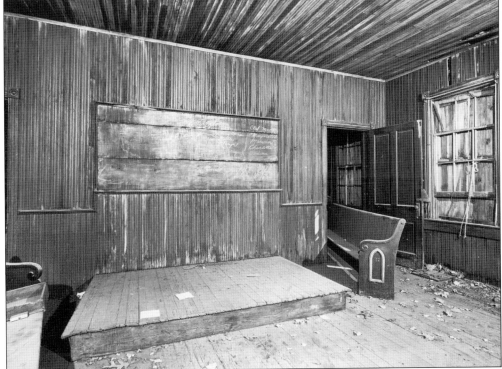

The abandoned Clifton High School on Main Street had a raised teacher's platform. The blackboard and architectural attention to detail made this a handsome building. (Courtesy Virginia Room, Fairfax City Library.)

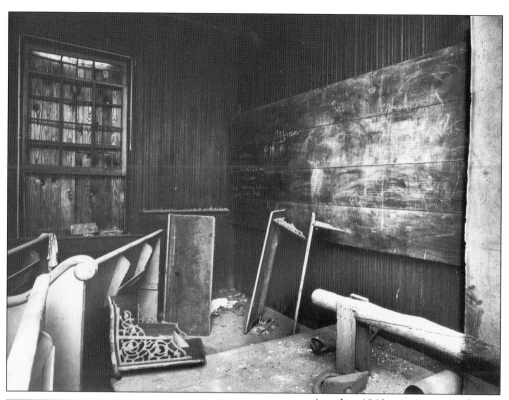

Another 1960s interior view shows the old Clifton High School. The appointments for this school were somewhat upscale to match the economic prosperity of the town. The tipped desks have fine metal detailing on the side. (Courtesy Virginia Room, Fairfax City Library.)

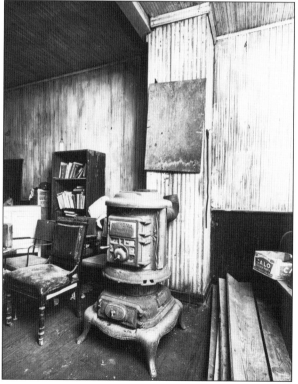

The abandoned Clifton High School woodstove included bookcases still filled with books. Additional blackboards and an ornate chair along with many other classroom accessories completed the room. (Courtesy Virginia Room, Fairfax City Library.)

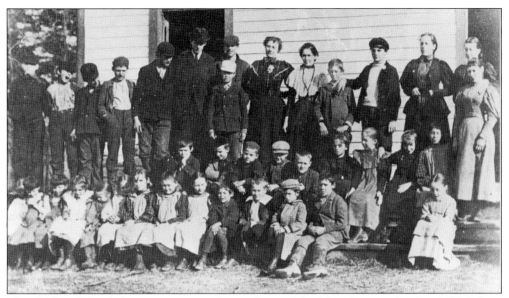

This Clifton School class picture was taken in front of the Main Street school in 1887. It later became the home of Mayors W. Swem Elgin and Jim Chesley. Jennie Buckley (back row, sixth from the right) was the teacher. (Courtesy Clifton Elementary School.)

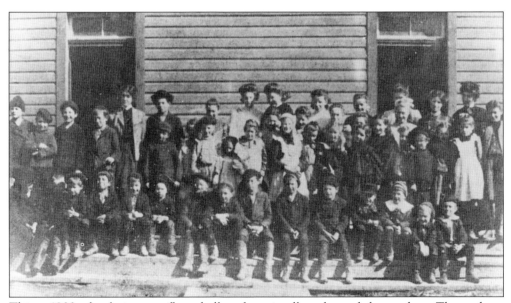

This c. 1900 school picture reflected all students in all grades and the teachers. The students are from the elementary school and possibly the high school across the street. (Courtesy Clifton Elementary School.)

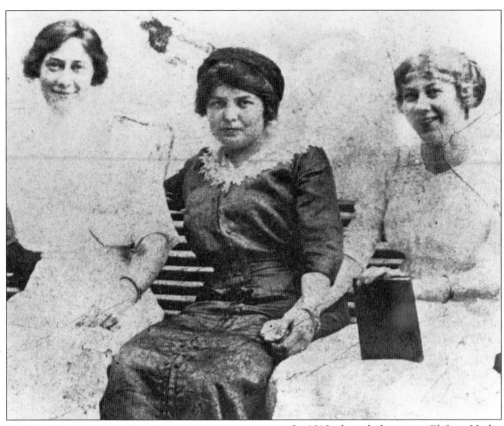

In 1910, these ladies were Clifton High School teachers whose families lived in town. From left to right are Pearl Payne, Barbara Cross, and Ruby Payne. Pearl and Ruby were sisters. As an economically developing town, it would have been advantageous to secure employment in Clifton and live nearby. (Courtesy Clifton Elementary School.)

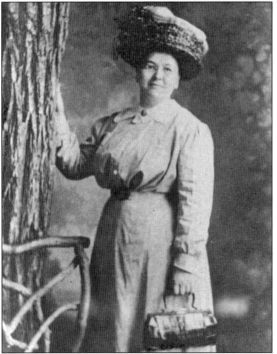

Virginia Ritenour came from the Shenandoah Valley in 1910 to be principal of Clifton High School. While living here, she married local man James U. Kincheloe, a descendant of longtime Clifton-area settlers. Several homes in Clifton offered boarding to local teachers. (Courtesy Clifton Elementary School.)

This 1916 view is of the "Mayors' Home"—later home to Mayors W. Swem Elgin and Jim Chesley. In the background is the former Clifton school. At this time, it would have been used for private, possibly residential space. (Courtesy Virginia Room, Fairfax City Library.)

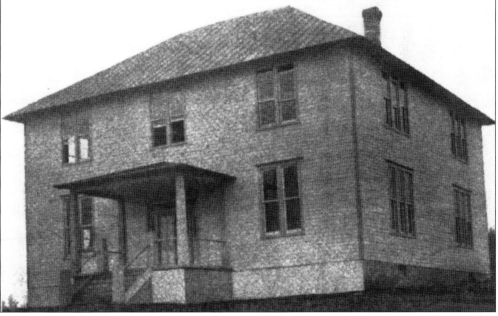

This imposing building high above the town of Clifton was opened in 1912 as Clifton's first official combined elementary and high school. It was considered one of the finest schools in Fairfax County. Its high location made access for the children difficult, and eventually a railing leading up the hill was installed for safety. (Courtesy Clifton Elementary School.)

Clifton School is seen with mature greenery and a bus in the background in the 1950s. Clifton purchased this prime piece of property from R. R. Buckley, who owned Buckley's Store. He later served on the Fairfax County Board of Supervisors. The school stood where the current Clifton Elementary School stands. (Courtesy Clifton Elementary School.)

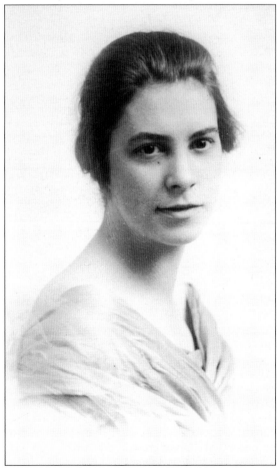

Xinnia Darrett Holmes was the 1912 Clifton High School's first principal. The class of 1919 included students Margaret Detwiler (later wife to Willard Webb), Annie Elgin, and Ruth Quigg. Their class motto was "Conquer We Must," and their colors were white and green. (Courtesy Virginia Room, Fairfax City Library.)

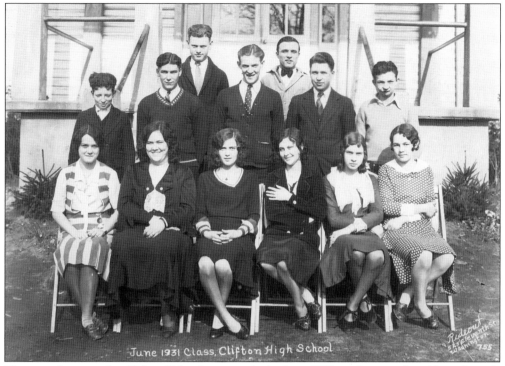

These students on the Clifton School steps were the June 1931 graduation class. Note the girls are wearing silk hose, which would have been an extravagant purchase and accessory at the time—a reflection of the economic well-being of the town. (Courtesy Virginia Room, Fairfax County Library.)

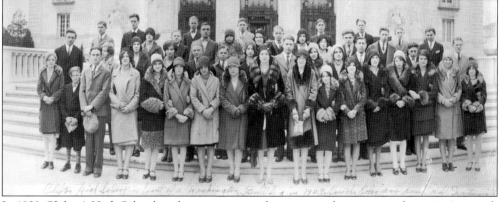

In 1929, Clifton's High School students were treated to an annual trip to visit the nation's capitol. The trip to Washington, D.C., was a special field trip and gave the local students a look at how the United States governed. Again note how well-appointed the female students are, with many wearing coats trimmed in costly fur. At the dawn of the 20th century and on into the 1930s, Clifton was a thriving community and enjoyed a number of firsts in Fairfax County, including being the first town to have electricity in 1905, generated from the nearby Bull Run Power Plant. As the lumbering industry and tourism to the town drew to a close and with the outbreak of World War II, the town suffered a significant down-turn, which would not right itself again until the early 1970s. From the late 1920s until the mid-1930s, Clifton enjoyed the end of what had been a thriving economy. (Courtesy Virginia Room, Fairfax City Library.)

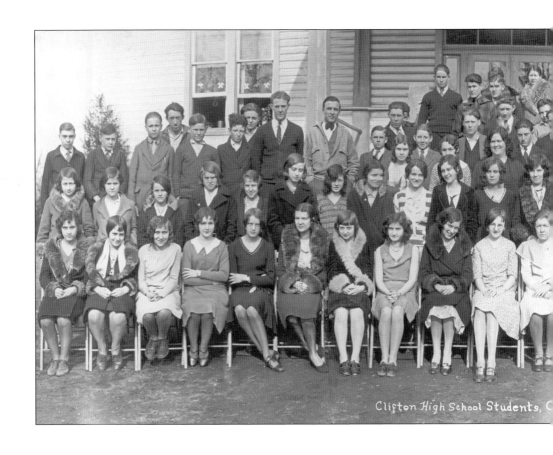

Clifton High School Students, C

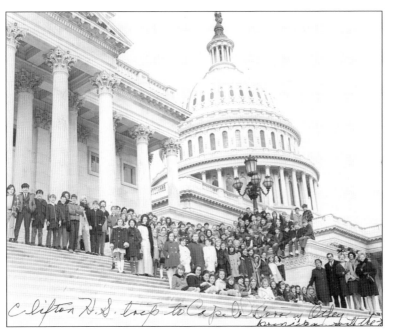

Clifton H.S. trip to Capital

Clifton Elementary School students enjoy a trip to the U.S. Capitol in 1968. This field trip to Washington, D.C., was one that the older elementary school grades would have enjoyed. Although it was a cold day outside, this group of students is truly enjoying the day. (Courtesy Virginia Room, Fairfax City Library.)

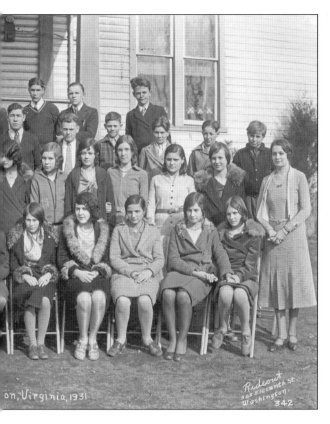

Clifton's 64 high school students from 1931 are poised on the steps of the school, indicating the school facility is becoming too small for the number of students. (Courtesy Virginia Room, Fairfax City Library.)

In 1951, students from one of the last classes in the old Clifton School gather before the new school was built in 1953. As always on class picture day, the older elementary school–age students are dressed for the occasion. (Courtesy Virginia Room, Fairfax City Library.)

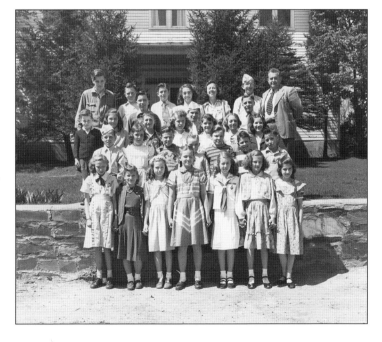

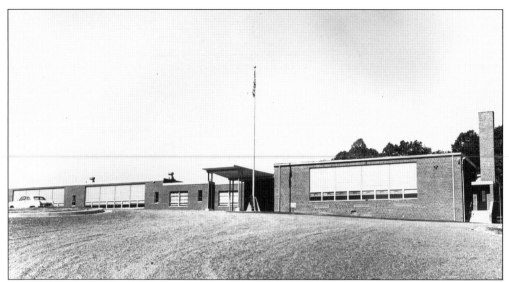

The 1953 Clifton Elementary School was considered modern and state of the art at the time. This is where children from the surrounding community attended. (Courtesy Virginia Room, Fairfax City Library.)

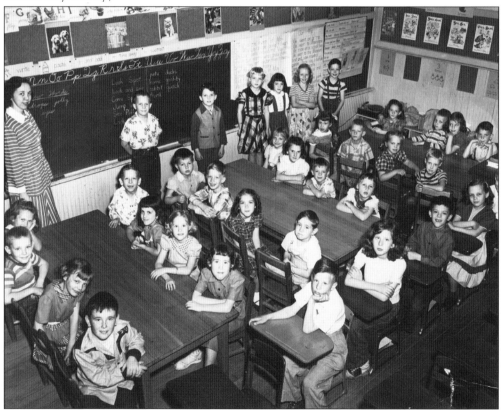

This *c.* 1958 Clifton Elementary School class includes a student named Mike Foley. Mike chronicled his memories of growing up in Clifton during the 1950s in a 2006 book, *From a Country Boy's View*, a summary of his simple Clifton country life. (Courtesy Mike Foley.)

These pages are from Clifton High School's 1935 yearbook. Assembled by hand, this 60-page book included individual photographs with stickers adorning most pages. The graduation class of 18 students, and a faculty of five teachers and a principal, required assemblage of some 30 books. Class officers were (above) Pres. Everett Koontz, Vice Pres. Stuart DeBell, Sec. Bellma Allen, Treasurer Mary Buckley, and sponsor Katherine Hopper. Their class flower was a rose, and their class colors were blue and yellow. Graduates included Randolph Burke, Harry Collier, Stuart DeBell, Walter Evans, Winter Hampton, Lawrence Hunsberger, Irwin Hurdle, Rick Johnson, Everett Koontz, Brook Mattingly, Ira Morris, Stanley Taylor, Bellma Allen, Mary Buckley, Thomas Mahoney, Randolph Mathers, Ruth Chesley, and Frances Palmer. Faculty were (below) George A. Watts, principal, and Katherine Hopper, sponsor. Other faculty included Bryan Teates, Annie Adair, Dorothy Dail, Inez Prince, and C. W. Beck. (Both courtesy Harvey Mathers.)

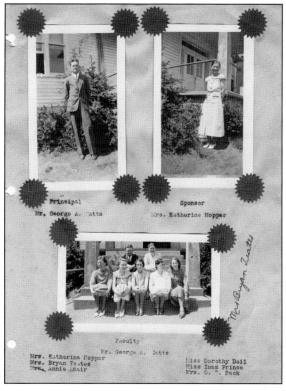

COMMENCEMENT PROGRAM

FOR

CLIFTON HIGH SCHOOL GRADUATING CLASS

CLIFTON BAPTIST CHURCH

8:00 P.M. June 2, 1935

Processional - War March of the Priests (Mendelssohn)

Invocation

Hymn - Faith of Our Fathers - No. 71 - Congregation

Scripture Reading

Hymn - Lead On, O King Eternal - No. 90 - Congregation

Sermon - Reverend S. Y. Craig, Clifton Baptist Church

Hymn - Onward Christian Soldiers - No. 91 - Congregation

Benediction

Recessional - War March of the Priests (Mendelssohn)

＊ ＊ ＊ ＊

(Congregation will please remain standing during both
processional and recessional)

The last graduating class of Clifton High School held a commencement religious service at Clifton Baptist Church on June 2, 1935, and a graduation/commencement program on June 6, 1935. During a time when most Clifton students attended one of the two main churches in town, singing religious hymns and holding a special graduation ceremony in a church was a common practice. The high school graduation ceremony would have been a solemn event, as only a few would have gone on to college. (Courtesy Harvey Mathers.)

CLIFTON HIGH SCHOOL COMMENCEMENT PROGRAM

CLIFTON BAPTIST CHURCH

8:00 P.M. June 6, 1935

Processional - Our Director (Bigelow)

Invocation

Introduction of Speakers............George Allan Watts

Vocational Guidance -
 What it is and what it isn't......Ruth Chesley, Honor Student

Song - Nancy Lee (Moore)............Members of Glee Club

Need of Vocational Guidance..........Frances Palmer, Honor Student

Teaching as a Vocation..............Mary Buckley, Honor Student

Medicine as a Vocation..............Everett Koontz, Honor Student

Song - My Cause (Wilson)............Members of Glee Club

Results of Vocational Guidance.......Bellma Allen, Honor Student

Song - Amid the New Mown Hay (Davies).Members of Glee Club

Presentation of Seventh Grade Certificates

Presentation of Diplomas............George Allan Watts

＊ ＊ ＊ ＊ ＊

(Audience will please remain standing during the processional)

Eight

THE BUILDINGS AND HOMES OF CLIFTON

Quaint, historic Clifton is home to 225 residents, changing little since the beginning of the 20th century. The town sits tucked in a valley, on a square half mile, surrounded by beautiful rolling pastures and horse country. Clifton can be busy, particularly in the spring to autumn months. It is a romantic destination for weddings; with two excellent restaurants and three historic churches, matrimonial bliss abounds. The oldest home in town is the Beckwith House, also known as "The Homestead." It is named for former plantation owner William Beckwith, who, before the Civil War, owned much of the property comprising Clifton today. Extensive renovations have quadrupled the original, cozy, three-room log cabin built around 1771. Of historic significance is the 1869 Clifton Hotel, which became the Hermitage Inn in 1987 and Trummers on Main in 2008. The hotel is on an 1869 plat drawn by county surveyor James P. Machen. It was conveniently located by the O&A Railroad Stop No. 6, Devereux Station, eventually called Clifton Station. During the last quarter of the 19th century, Clifton became a major resort town, enticing Washingtonians to the cooler summer air of the little valley and the fresh, rejuvenating waters of nearby Paradise Spring. After a hotel, churches and schools were established and homes and businesses became an essential architectural component of the town. Carrying all the ambience of a late-19th-century railroad town, with Victorian-style homes and Gothic revival designs, the town is a picturesque destination for many. James Hricko, former neighbor, architect, and author of the Historic District Ordinance wrote, "Clifton's ensemble of streets, open spaces and building sites is a lesson in environmental design. . . . The closeness of the buildings to the street suggests a slower-paced time when social life centered on the street and large front porches attended to it."

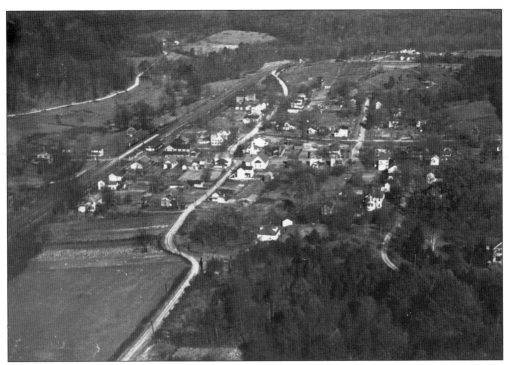

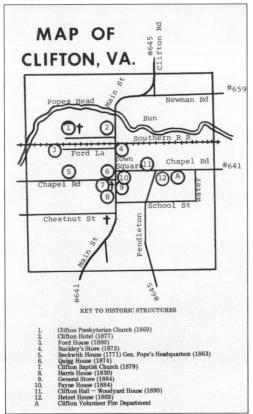

MAP OF CLIFTON, VA.

#645 Clifton Rd

Popes Head

Main St

Newman Rd

#659

Run

Southern R R

Ford La

Town Squar

Chapel Rd

#641

Chapel Rd

School St

Water

Chestnut St

Pendleton

Main St

#641

#645

KEY TO HISTORIC STRUCTURES

1.	Clifton Presbyterian Church (1869)
2.	Clifton Hotel (1877)
3.	Ford House (1880)
4.	Buckley's Store (1872)
5.	Beckwith House (1771) Gen. Pope's Headquarters (1863)
6.	Quigg House (1874)
7.	Clifton Baptist Church (1879)
8.	Harris House (1830)
9.	General Store (1884)
10.	Payne House (1884)
11.	Clifton Hall — Woodyard House (1890)
12.	Hetzel House (1869)
A	Clifton Volunteer Fire Department

This 1937 aerial view of Clifton reflects how little Clifton has changed through the years. Note the following buildings: Red Gables, the Ayre House, and Ferndale. In the center of town, the Quigg and Payne houses, the Clifton Baptist Church, Buckley Store, train depot, hotel, and railroad are clearly visible. (Courtesy Virginia Room, Fairfax City Library.)

This map, showing streets, homes, and buildings, was used for a Clifton walking tour brochure, designed by the Clifton Betterment Association. The town churches are all marked with a cross. Local legend has the Beckwith House serving as General Pope's headquarters, yet no supporting documentation has been found. (Courtesy Donna Netschert.)

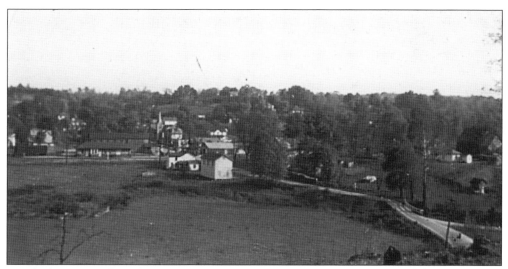

A red caboose sits where the train depot welcomed travelers. The Clifton landscape has changed little since the dawn of the 20th century, with the current abundance of trees the biggest change. As a thriving lumber center in the early 20th century, Clifton's lumber businesses slowly dwindled as a number of trees were cut, milled, and sold for railroad or building lumber. (Courtesy Acacia Lodge No. 16.)

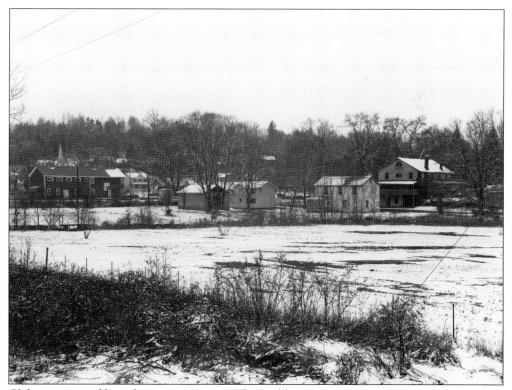

Clifton is pictured here during a 1968 snow. The Buckley store, Acacia Lodge No. 16, and Clifton Hotel are distinctly visible. This is unmistakably historic Clifton. (Courtesy Virginia Room, Fairfax City Library.)

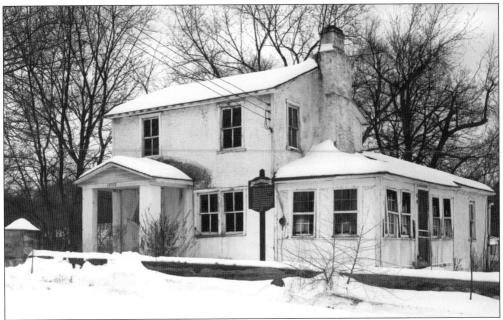

The Beckwith House, or "The Homestead," shown in 1968, is Clifton's oldest home dating to approximately 1771. David and Donna Bean built a large addition and made extensive renovations to the home. It now has an L-shaped addition and is a welcoming, handsome structure. (Courtesy Virginia Room, Fairfax City Library.)

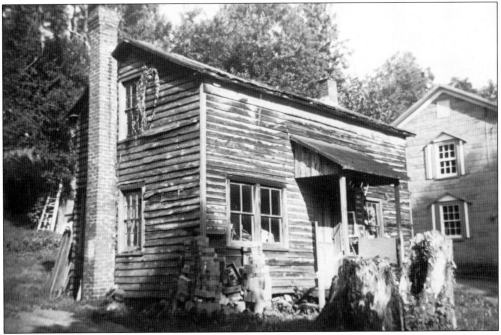

This house on Dell Avenue, shown in 1965, and a number of small, similar structures were built on this lane at the edge of Clifton in the 1930s. Their "cottage" design has been enhanced by new owners who have added period additions and more extensive front porches—all within keeping of Clifton's Victorian-era atmosphere. (Courtesy Karns and Weaver families.)

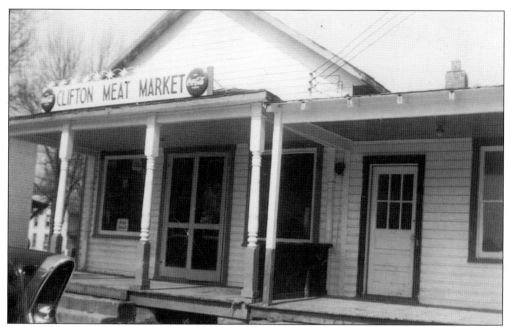

The Clifton Meat Market, here in 1958, is one of several establishments this building has housed, including a mercantile establishment, lighting store, bakery (where Doug Detwiler says the best donut twists in town were sold), the Deb-Lor cabinet shop, a tea room, a print shop, a pool hall, and Clifton's Episcopal church (1906–1922). It is currently Clifton's only bed-and-breakfast, the Canary Cottage. (Author's collection.)

This 1958 side view of the above building shows the lack of landscaping and simple, though drab, appearance of the type of building that was once only one step off Main Street. Most of Clifton did not have in-house running water and plumbing until the 1960s, and this building was no exception. This area is now a beautiful, bricked courtyard to the bed-and-breakfast establishment. (Author's collection.)

This house on Dell Avenue is shown in the 1930s. Hazel Mary Manuel was adopted, born Bertha Frances Kelly, and her Clifton ancestry is a mystery. She lived here, was later raised by Maryland relatives, and once carried the same last name as Rev. Alford Kelly, former pastor of the Clifton Presbyterian Church. She is currently unraveling these mysteries. (Courtesy Karns and Weaver families.)

This picture of the same home includes the Weaver and Morgan ladies. Sarah Weaver's husband, Virgil, owned the Weaver store, now the Clifton General Store. A hot grill featuring a "Clifton Breakfast Taco" offers a delicious meal for the 12,000 daily commuters who now drive through Clifton. (Courtesy Karns and Weaver families.)

Virgil V. and Sarah Weaver built and moved into this Main Street house located next to their store. The original home burned in the late 1930s. Former Clifton resident Doug Detwiler remembers his mother taking him as a small boy to watch the disaster. The building is now home to a kitchen renovation shop and a coffee shop. (Courtesy Karns and Weaver families.)

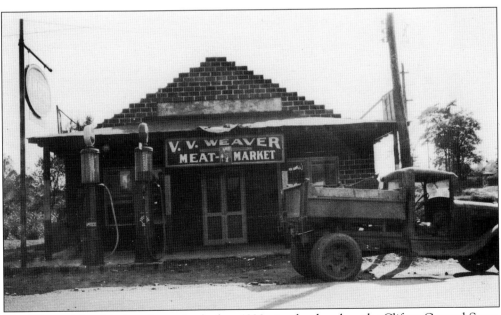

The Weaver Meat Market, shown in the late 1930s, is a landmark as the Clifton General Store. Their shop burned when, having just purchased a new freezer, the voltage was apparently too strong for the wiring and an electrical fire ensued. (Courtesy Karns and Weaver families.)

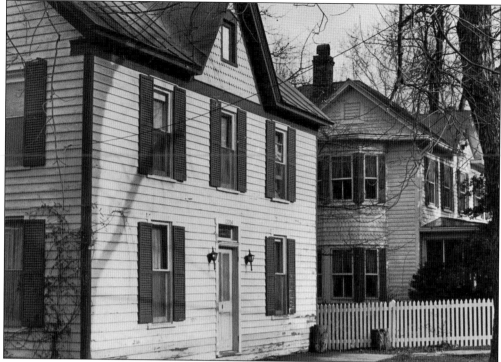

This fine-looking cottage on Main Street, pictured in 1982, once belonged to a town lumber merchant near one of the town's large lumber mills. So busy were the mills, the lumber piled up and was stored anywhere possible awaiting railroad shipment, often making street traffic difficult. This building was most recently a gift shop, Basket and Boughs. (Courtesy Jennifer Heilmann.)

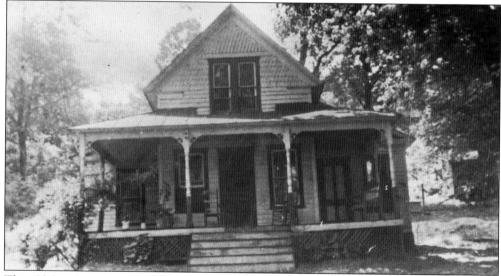

This Clifton bungalow on School Street was built in the 1930s. Now home to the Kirsten Thompson family, it underwent significant renovations during the 1980 and 1990s. Featured on the 2006 Historic Clifton Candlelight Homes Tour, and decorated in an enchantingly beautiful, romantic Scandinavian style, it was a treat to all. Even the barn out back (with donkey and pony) was decorated with greens and candles. (Courtesy K. Thompson.)

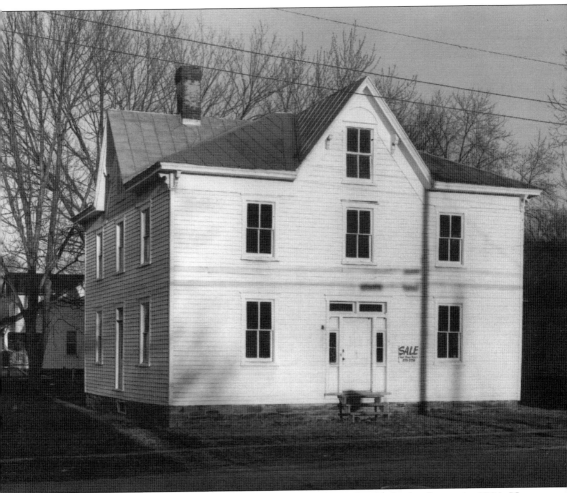

Melvin M. Payne was a successful Clifton lumber merchant. He built this house in 1884. He acquired, along with the Buckley brothers, a large, central part of the town and then resold the parcel in smaller lots. Quite wealthy by virtue of his lumber business, he partnered with neighbors Lewis Quigg and W. E. Ford. The *Fairfax Herald* referred to his lumber stock by saying, "the prices are low and his stock is extraordinarily good." After Melvin died, his wife, Lucy, sold the business to other townsfolk, who, unfortunately went bankrupt. She and her sister, Molly Cross, boarded schoolteachers and others to provide a sustainable source of income. At one time, the house had a wraparound porch and became home to Lee and Virginia Ruck, then Robin and Kathy Beard. It is now home to the Mills family. Mary Mills is owner of Fil-i-gree Home Accessories across the street, next to Heart in Hand restaurant. (Courtesy Virginia Room, Fairfax City Library.)

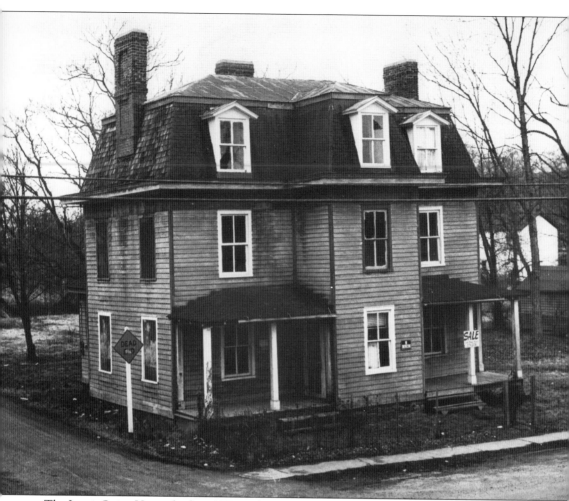

The Lewis Quigg House, built in 1874, is shown in the 1960s and was considered one of the most elaborate and distinctive Clifton homes. Quigg, a wealthy dairy farmer and businessman, sold his Clifton General Store to the Buckley brothers and was able to retire soon after he married Mary Emma ("Mamie"), a "city girl" who was 25 years his junior. He was also Clifton's postmaster from 1890 to 1894. Mamie Quigg reputedly took a horse-and-buggy ride around the village every day at 2:00 p.m. wearing her most elegant finery. They had seven children. A depiction of the house appears in an 1882 published panorama of Clifton. Lou Quigg died in 1914, and Mamie died in a tragic automobile accident in 1929. In the 1970s, architect Jim Hricko renovated the home for his family's residence, currently occupied by Clifton mayor Tom Peterson and family. (Courtesy Virginia Room, Fairfax City Library.)

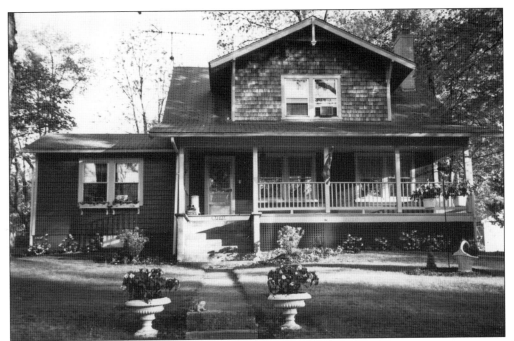

Jack Moore Detwiler and Lillian Prince Detwiler built this house at 12821 Chestnut Street in 1931 and lived here with their son, Doug, until 1964. The home cost $3,500 and was constructed by Doug's great-uncle Oscar Detwiler and his sons, Bill and Lewis. The home was very modern for its time and had a one-car garage, coal-fired water heater, running water, inside plumbing, and electricity. (Courtesy Alesia Harvey and Doug Detwiler.)

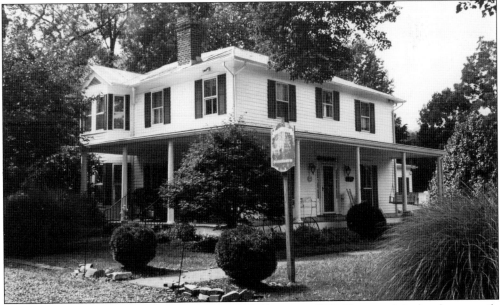

W. E. Ford, an early Clifton entrepreneur, built this house in 1880. He owned the local mercantile shops with Robert R. Buckley and Melvin Payne. Situated immediately adjacent to the railroad, Ford Lane was one of the town's busiest streets. The photograph reflects the significant restorations made in 1969 by David and Diane Smith. (Courtesy Kathy Baber.)

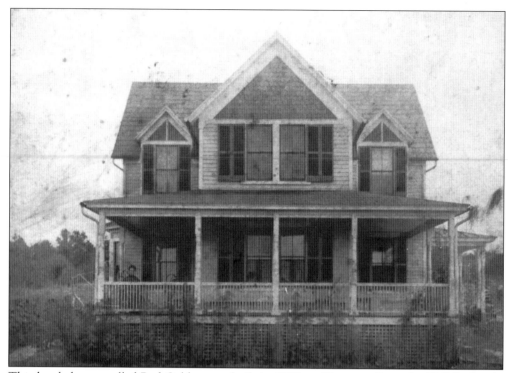

This lovely home, called Red Gables, was built in 1908 on Chestnut Street by Will Richards. Katherine Richards is sitting on the porch around 1910. Often referred to as the Mynor McIntyre House (home of mayor of Clifton, 1976–1982), it was the childhood home of Clifton resident Malcolm McIntyre. Travis and Suzi Worsham purchased the property in the 1980s and made significant renovations, including a swimming pool and a log cabin brought to the site. In 2005, they added a large two-story garage to the property. The home has frequently been on Clifton Home Tours, and its spacious kitchen allowed Suzi to try many new recipes before they were added to the menu at her Heart in Hand restaurant, located on Main Street. (Courtesy Malcolm McIntyre.)

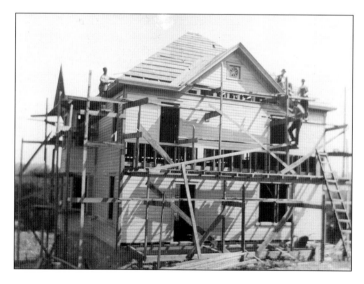

The Elmer Ayre house was under construction in 1913 on Chestnut Street. A tremendous amount of scaffolding was used as the wooden clapboard house was being built. This handsome house would have been one of the finest in town. The Ayre family was a strong presence in the town, with T. A. Ayre one of the first depot operators. (Courtesy Virginia Room, Fairfax City Library.)

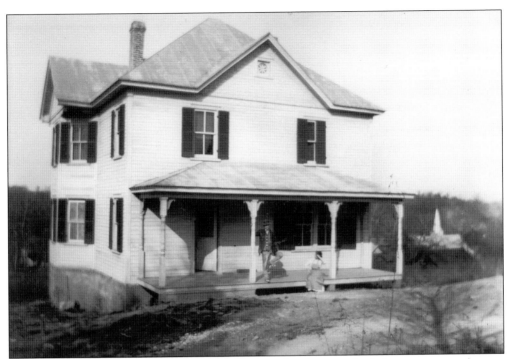

In this photograph of the finished Ayre House, it is clear how much of the tree area was barren. The center of town is today called Ayre Square, and the small piece of property remains in Ayre family possession. (Courtesy Virginia Room, Fairfax City Library.)

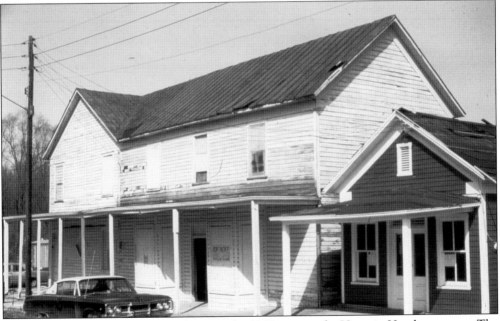

The 1891 Buckley Brothers Store, shown in the 1960s, is now the Heart in Hand restaurant. The original Clifton Station railroad depot sat here. Land records show M. M. and Lucy Payne with Lewis Quigg purchased the 50-by-100-foot lot on the east side of Fairfax Street, 30 feet south of the railroad, for $150. (Courtesy Virginia Room, Fairfax City Library.)

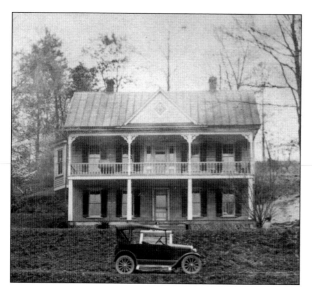

One of Clifton's most handsome homes was built in 1908 by the Poindexter family. Margaret Detwiler Webb then lived here and enjoyed painting in the 1920s. She passed the property to her grandson, Ruel Fugett (known as Scobie), and his wife, Catherine D. Fugett, who then lived here until 1961. Ruel was a first cousin to the actress Helen Hayes. She would often visit Ferndale in the summertime and found she enjoyed the peace and quiet of Clifton. The land originally belonged to the Harris heirs and is now owned by Chuck and Helen Rusnak. (Courtesy Barrett and Webb families.)

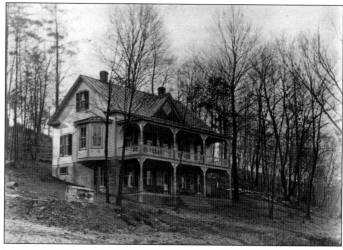

This 1908 postcard was found many years later in an antique store by neighbors Emmett and Ellen Barrett. It reflects a family of comfortable means who shared the news of a new home in such a manner and, in this case, the form of a holiday greeting. The card is addressed to Mrs. Henry Howard, Brookeville, Maryland. Laura and R. H. Poindexter lived here until his death in 1919.

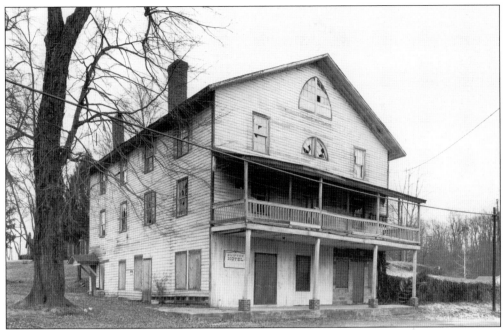

The Clifton Hotel, shown in the 1960s, is one of Clifton's oldest buildings, originally owned by Harrison G. Otis, who purchased land from the Beckwith estate in 1869. Legend says on an evening train ride through Clifton, Otis heard a wandering pig squeal in a vineyard with intoxicated delight and thus came Otis's vision of grape harvesting and land development. (Courtesy Virginia Room, Fairfax City Library.)

These ladies are sitting around 1910 on the balcony of the Clifton Hotel, when the hotel enjoyed a complete wraparound porch on the second floor and an auspicious presence in the surrounding area. The Acacia Lodge No. 16 can be seen in the background. (Courtesy William Baumbach and Michael Rierson.)

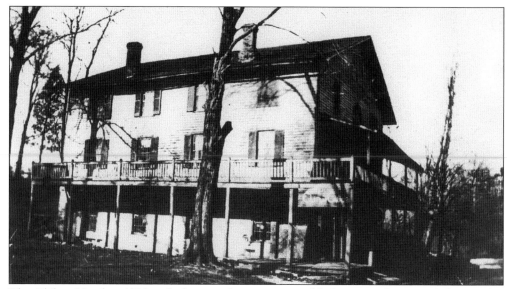

The Clifton Hotel in 1936 with the complete wraparound balcony on the second floor is also visible on the book cover. The Clifton Hotel was sold in 1889 by Mary Otis to a Mr. Carmichael of New York. It later became a boardinghouse and provided inexpensive housing for World War II war brides. Over the years, it has served as an apartment building and the first floor as a car repair garage. (Courtesy Harvey Mathers and Ed Parker.)

This set of stained-glass doors once graced one of the suites of the Clifton Hotel. Prior to installation at the hotel, they were the interior decoration of a Trans-Atlantic steamship. They are now installed in the Canary Cottage Bed and Breakfast in Clifton. (Courtesy Harvey Mathers and Ed Parker.)

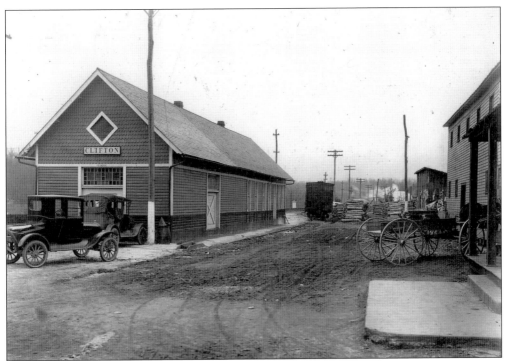

The Clifton Railroad Depot and Buckley store are seen in 1927. Note the mix of early automobiles and horse-drawn carriages. In the background are stacks of lumber readied for shipping on the railroad. A red caboose now marks the depot location in a park-like setting. (Courtesy Virginia Room, Fairfax City Library.)

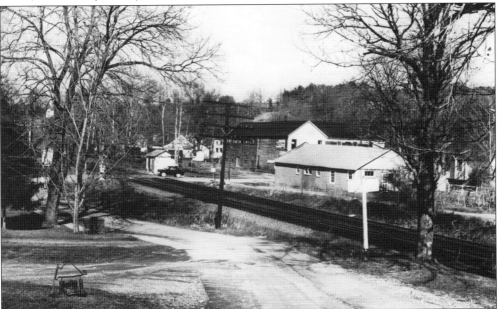

The Clifton Depot area is pictured in the 1950s, with the Buckley Brothers Store, the Clifton General Store, and Ford Lane easily seen. The treeless hill in the background was once used for the town dump. (Courtesy Virginia Room, Fairfax City Library.)

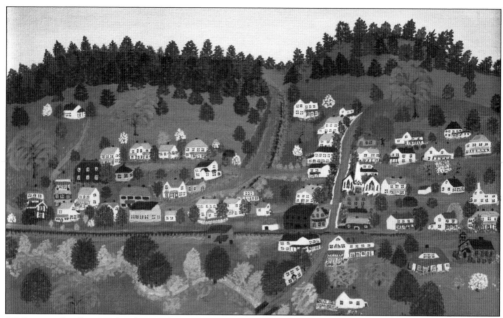

Clifton is the featured subject above in "Summer" (above) and "Winter" (below), both by artist Oscia Mathers, Harvey Mather's aunt and Jay Waverly's wife, c. 1960. The home and businesses from left to right are School Street (back street left): Fletcher, Picken, Detwiler, Quinn, Poe, Johnson, Smith, Woodyard, Pumphrey; Chapel through Pendleton Ave. (front street left): Spindle, Croson, Spindle, Koonz, Kidwell, Detwiler, Beasley; left side of Main Street (road crossing railroad): Hickey, Buckley Store, Payne, Kincheloe, Wood, Ford, Elgin and Morris Davis; right side of Main Street: Weaver Store, Weaver, Quigg, Longerbeam, Kidwell, Buckley; Ford Lane: (front street right adjacent to railroad): Bryant, Davis, Smith; Chapel Street (middle street right): Fulmer, McMillen, Beckwith and Buckley; Chestnut Street (back street right): Cross, Merchant, Buckley and Ayres. (Artwork courtesy Harvey Mathers; photography courtesy Ed Parker.)

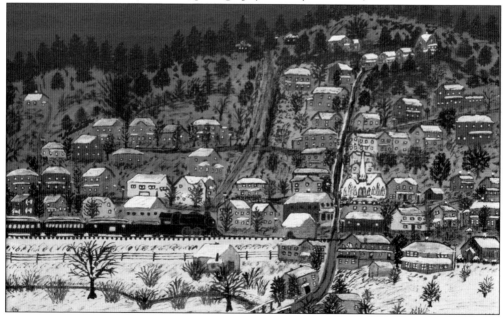

Nine

THE PEOPLE OF CLIFTON

Many early Clifton settlers were "Yankees." In 1904, the *Fairfax Herald* published a description of the town and tradesmen here as an enticement for Northerners to come and invest. Trades included two general store owners, lumber dealers, blacksmiths, a wheelwright, undertaker, butcher, barber, mill owners, teachers, farmers, pastors, and several citizens commuting via train into Washington, D.C. Acacia Lodge No. 16 was established in 1877 by Gen. George P. Wright and A. J. Kidwell. It was long a stabilizing and ethical force in the community, and most male settlers were members. Clifton resident and sea post clerk Oscar Woody was a member of the Clifton lodge. Woody died on the *Titanic* in 1912, and his Masonic dues card for Acacia Lodge No. 16 and Masonic pocketknife were found on his body. Masons were present at the laying of various local building cornerstones, including the Clifton Baptist Church (1910) and Kate Waller Barrett Memorial Chapel at Ivakota Farm (1926). Colorful and well-known visitors to Clifton include Presidents Rutherford B. Hayes (a close personal friend to John Devereux), James Garfield, and Theodore Roosevelt. During November 1877, former president Grant met John Singleton Mosby at the Clifton Hotel to discuss continued efforts towards ongoing peaceful North/South relations. The farm where the hotel stands boarded Grant's horses for several years. Helen Hayes, a cousin to Ruel Fugett, frequently visited Clifton. First Lady Nancy Reagan dined at Heart in Hand with George Will. The opening scene of Hollywood's *Broadcast News* was shot here. Jeff Arch wrote the screenplay to *Sleepless in Seattle* here. Congressman from Tennessee Robin Beard lived here. The Webb family donated their property atop Chestnut Street to the Audubon Society, now a beautiful destination for nature lovers. Today's citizens comprise an enterprising mix of attorneys, accountants, veterinarians, corporate executives, military leaders, teachers, artists, musicians, academic deans, doctors, aerobic/yoga instructors, and even an astrologer. Passions run high in Clifton to protect the historical heritage and aesthetic attractiveness with a "work hard and play hard" energy. Annual town events include Clifton Day, the Clifton Community Women's Club Homes Tour, and the Town of Clifton's Annual Candlelight Tour held the first Saturday of December.

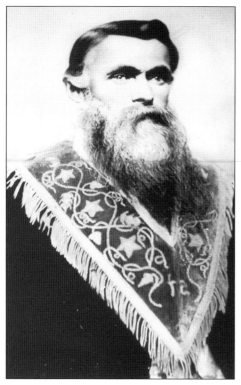

In 1877, Northerner and Civil War general George P. Wright (left) was appointed Worshipful Master by the Masonic Grand Lodge and helped petition to have Acacia Lodge No. 16 at Clifton Station. Born in New York City, he was credited with encouraging positive relations between the North and South. He was a passionate contributor to the Masonic Fellowship and Clifton. A. J. Kidwell (below) was the town blacksmith and member of the first Clifton Town Council. After incorporation in 1902, Kidwell and Wright were a formidable pair in installing the lodge's governance and Clifton affairs. They are buried side by side in the Clifton Cemetery. (Above courtesy William Baumbach; below courtesy Virginia Room, Fairfax City Library.)

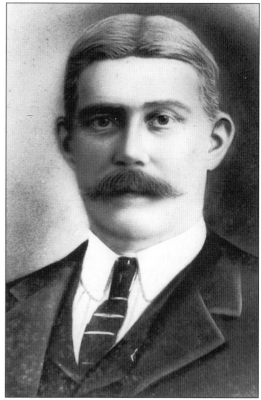

In January 1906, the *Fairfax Herald* wrote an overview of the enterprising businesses in Clifton, including Kidwell's blacksmith shop: "The up-to-date blacksmith conducts a business second to none in the county of Fairfax. He knows more about horses and horseshoeing than anyone . . . is always courteous and polite yet firm in his manner; at all times a leader in movements to street improvement." (Courtesy Virginia Room, Fairfax City Library.)

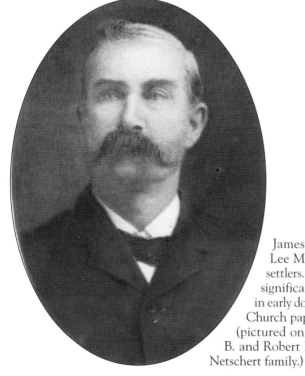

James B. Cross (1853), pictured, and Cora Lee Mathers Cross (1854) were early Clifton settlers. Settling on Chestnut Street, they were a significant force in town, their names appearing in early documents, including Clifton Presbyterian Church papers. Their children were Barbara Ann (pictured on page 66), Roger William, and James B. and Robert E. Cross. (Courtesy Steve Bittner and Netschert family.)

Scribbled on the back of Cora's photograph are the words, "Lived her entire life in Fairfax County. A good Woman!," likely penned by James Cross. James was Clifton's first undertaker, a wheelwright, wagon builder, blacksmith, magistrate, member of the first town council, and later Clifton's mayor. (Courtesy Steve Bittner and Netschert family.)

Virgil V. Weaver and his wife, Sarah (nicknamed Sallie), were the owners of Clifton's butcher shop and meat market. They lived next door and sadly saw their property go up in flames in the late 1930s yet stayed and rebuilt. Another Weaver was the original owner of the manse (cleric house) on the Clifton Presbyterian Church property, now an education facility. The Weavers are related to Hazel Mary Manuel (née Frances Kelly). The Weaver store is now the Clifton General Store. (Courtesy Karns and Weaver families.)

Popes Head Creek flooded with a vengeance in 1936. This picture shows young Clifford Taylor (left) and Jesse Fairfax peering over the bridge at the town "flood plain." In 2006, Clifton experienced another "100 years" flood; then Popes Head Creek went completely dry during the drought of 2007. (Courtesy Virginia Room, Fairfax City Library.)

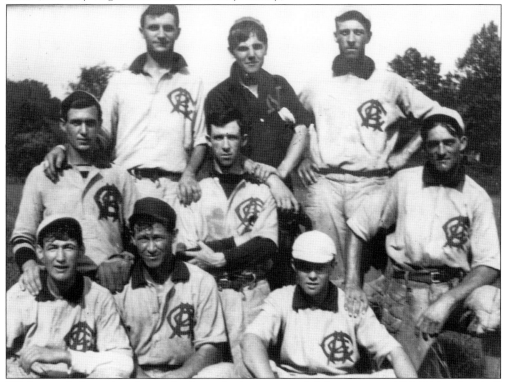

"Cliftonites" always found time for fun and relaxation, as did this winning 1903 Clifton baseball team. Called the "Hungry Nine," they played teams from Del Ray, Oak Grove, Manassas, Vienna, and Leesburg. Their competitive spirit let it be known they would play any team within a 50-mile radius. (Courtesy Virginia Room, Fairfax City Library.)

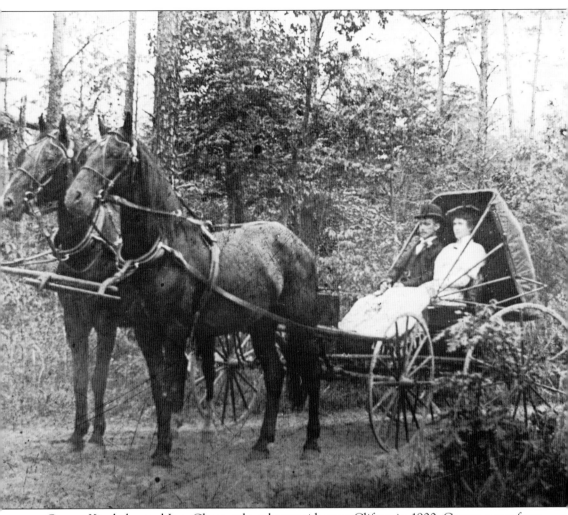

George Kincheloe and Inez Gheen take a buggy ride near Clifton in 1900. George came from a long line of Clifton-area settlers preserved in perpetuity with the naming and donation of a nearby soccer field, Kincheloe Park. (Courtesy Virginia Room, Fairfax City Library.)

One of Clifton's most distinguished citizens was Willard Webb. Serving in World War II, he received his promotion to brigadier general as his book *Crucial Moments of the Civil War* went to press. He served in the 20th Armored Division in the Pacific theater. As a civilian, he headed the Library of Congress Stacks Division for many years. He married Margaret Detwiler nearly 10 years after having met her and claimed he knew at once he wanted her for his wife. Webb served as an elder at Clifton Presbyterian Church and contributed numerous bas-relief wood carvings that were cleaned and remounted for the church's 2007 dedication of its new wing. (Courtesy Virginia Room, Fairfax City Library and Willard family.)

This war ration book was used in 1944 by Clifton citizen Elsie Blevins. She married James William Blevins, and their daughter, Virginia Darnell, still lives in the area. This booklet provides an insight into life during World War II and shows how much recycling was part of the military effort. (Courtesy Virginia Darnell Hoose.)

Elsie and her sister Viola (on the pony) pose on the family farm in 1929. The Blevins family farmed a considerable amount of land at "Blevinsville," its informal name. Grandma Blevins spun wool using a wool walking wheel, churned her own butter, and pressed her own sausage. (Courtesy Virginia Darnell Hoose.)

Clifton's current and future mayors in the 1980s are at a Fourth of July picnic. From left to right are Jim Chesley, Pinkie Anchor, and Wayne Nickum, who served on the town council and have worked endlessly to maintain the historic integrity and architectural aesthetics of Clifton. (Courtesy Virginia Room, Fairfax City Library.)

Jim Wells poses with his famous and colorful popcorn machine at the 1968 Clifton Days. Begun in the late 1960s, the annual event now draws 15,000 visitors the first Sunday in October. Food vendors, antique dealers, craftspeople, musicians, and children's entertainment mark this special event in which virtually every town citizen participates. (Courtesy Virginia Room, Fairfax City Library.)

Ruel "Scobie" and Katherine Detwiler Fugett (left) owned Ferndale until 1961. At the end of Chapel Street, this handsome two-story, double-balconied home is a wonderful testimony to the economic plenty of the early 19th century. John Huntsberger Detwiler (shown below in 1906) was a frequent visitor to Ferndale as an adult. His family's legacy and descendants are plentiful in town. Ruel's cousin, actress Helen Hayes, frequented Clifton to get away from the hustle and grind of her stage life. Ferndale is often called the Helen Hayes House. (Courtesy the Detwiller and Webb families.)

Doug Detwiler was related to many town citizens, including the Webbs and Fugetts. Raised on Chestnut Street at Acorn Ridge, his "institutional knowledge" of the Clifton area and Ivakota Farm is significant. He is still an active member of Acacia Lodge No. 16 and resides in Fredericksburg. (Courtesy Detwiler family.)

This unidentified individual is in keeping with Clifton's commitment to overall maintenance and dedication to 'curb appeal' aesthetics. Although the town suffered an economic decline from the late 1930s to late 1960s, the 1970s saw regentrification of the community, sustined through today. (Courtesy Virginia Room, Fairfax City Library.)

Dr. Kate Waller Barrett and her adult children are pictured at her home on Duke Street in Alexandria in 1922. Her children played significant roles around Clifton. Reba and John ran Ivakota Farm for years, and Kitty lived in Fairfax City, devoting her life to gardening and civic activities. Maj. Gen. Charles Barrett headed the committee that wrote FTP-167, the first doctrine used by the fleet for amphibious operations, the reason the U.S. Marine Corps is recognized as an authority in landing operations. Considered one of the "most energetic, imaginative and original thinkers of the Marine Corps," he died early in World War II. (Courtesy Smith and Barrett families.)

Rush Buckley, Clifton's first Rural Free Delivery carrier is shown in 1907, when he was working for the U.S. government. The 100th anniversary of Rural Free Delivery in Clifton was held on July 28, 2007. Acacia Lodge No. 16 member Don McAndrews reenacted Benjamin Franklin at the ceremony coordinated by the town history committee. (Courtesy Clifton Post Office and Lee Hubbard.)

This postage stamp was designed for the Jamestown 2007 celebration and affixed to the special Clifton envelope designed by Phoebe Peterson to commemorate the 100th anniversary of Rural Free Delivery in Clifton on July 28, 2007. The town history committee resurrected the practice of publishing annual envelopes capturing a local historic building, such as the old Clifton Post Office. (Author's collection.)

Mayor Wayne Nickum shakes hands with First Lady Nancy Reagan while George Will looks on. Nancy Reagan was a fan of Clifton and often enjoyed lunch at the Heart in Hand restaurant. Mayor Nickum is credited with having the vision and energy to place Clifton on the National Register of Historic Places in 1985, the same year Clifton was filmed for the opening scenes of the movie *Broadcast News*. Other notable town events include the writing of the screenplay for *Sleepless in Seattle* by Jeff Arch, who resided in the Buckley house on Main Street, now home to Paul and Arlene Posner. (Courtesy Wayne Nickum.)

Ten

CLIFTON TODAY

Regentrification of Clifton began in the late 1960s, and the town has become a thriving, bustling, and economically prosperous village once again. Young couples brought their energy and vision to this lonesome village after the lumber and tourist industries died. Much improved with access to indoor plumbing for citizens, the town still sits on a septic system. Street improvement and traffic issues, along with the enjoyment of an occasional "adult beverage," have long been part of Clifton's history. Her citizens love her immensely, have passionate conversations about her protection, and strive to serve endlessly in a variety of civic functions. The 2008 town council is an excellent representation of longtime residents and those living in newer neighborhoods. Clifton's citizens hail from all over the nation and world, each bringing their own particular brand of ingenuity to ensuring the town is maintained with integrity. In 2002, Clifton celebrated its 100th anniversary of incorporation. A three-day festival marked the occasion over the Fourth of July weekend. The traditional Fourth of July parade/picnic was amplified by a sunrise walk through the Webb Audubon Preserve, a brunch at the Acacia Lodge No. 16, and an interfaith service held at the park gazebo with leaders of the Clifton 100th Anniversary Ecumenical Order of Worship: Fr. Paul Dudzinski (St. Clare Catholic Church), Rev. Julie E. Hodges (Clifton Presbyterian Church), Rev. Dr. George Comfort (Second Baptist Church of Clifton), and Rev. Carl Staats (Clifton Baptist Church). An evening concert was held with entertainment provided by local musicians. A history display was set up in the town meeting hall, and event T-shirts were sold. A 100th anniversary time capsule was also buried in front of the gazebo—with the intent to be opened in 2027. Families contributed stories and personal artifacts to reflect life in 2002. The stone marker placed over the buried capsule read, "In honor of Clifton's 100th Anniversity"—a perfect, humorous way to reflect a world and time all Clifton citizens love.

Clifton mayor Phyllis Waters (1972–1976) provides welcoming remarks for the Clifton Community Women's Club (CCWC) at their 1974 Annual Spring Homes Tour reception. On the left is Jean Packard, Fairfax County chairperson of the Board of Supervisors. The mayor's sister stands between them. The CCWC was organized in 1971 and is a vital contributor to the health and social awareness of Clifton. (Courtesy Clifton Women's Community Club.)

Numerous volunteers make the CCWC Spring Homes Tour a success: ticket sellers, homeowners who share their homes, docents, and advertisement sellers. Dozens of women work hard to make this successful event a fund-raiser for local charities and scholarships. Shown in 1974 from left to right are Lee Burnham (chairperson of the tour), Arlene Straubel, Viola Kelpy, Kim Burnham, and Jean Packard. (Courtesy Clifton Community Women's Club.)

Jim Chesley (right) takes the oath of mayor as administered by Fairfax clerk John Frey (left) in 1992 on the steps of the newly renovated Hermitage Inn and Restaurant, formerly the Clifton Hotel. Jim played a most active role in ensuring surrounding jurisdictions and civic groups participated in the preservation of Clifton. (Courtesy Jim Chesley and Steve Reda.)

Clifton citizens Mark and Diane Reimers, here in 1980, have both been remarkable town volunteers. Active in the Boy Scouts and serving assiduously at Clifton Presbyterian Church, Mark was named "1980 Volunteer Citizen of the Year." Their volunteerism extends to Kenya, Africa, providing missionary work in developing a school/orphanage for AIDS-infected babies. (Courtesy Marla Hembree.)

Kirsten Thompson's house is a beautiful example of the regentrification efforts Clifton enjoyed during the past three decades. She has been an active mother and artist and currently sits on the town Arts Council. Her home has been a welcome location for several Clifton social functions. (Author's collection.)

Horses have always been a part of Clifton's history, and these young ladies in 1980 are enjoying a stop in town. No doubt many Confederate and Union Virginia Cavalry men rode through this area, now a pastoral and bucolic destination for horseback riders. (Courtesy Virginia Room, Fairfax City Library.)

Former Clifton residents, these sisters grew up in Clifton and returned in 2006 to stay at the Canary Cottage Bed and Breakfast. Josephine Andes (left) and Shirley Mock (right) had lived in the Hetzel House while children. They were amazed at how very little the town had changed since their childhood. (Author's collection.)

"Pat Herrity for Springfield District Supervisor" supporters marched in Clifton's Fourth of July parade in 2007. Pat's father, Jack, served as chairperson of the Fairfax County Board of Supervisors. Pat was elected to fill the role left behind by Fairfax's great lady, Elaine McConnell. (Author's collection.)

The Haunted Trail, Clifton's most recent and successful annual event, is a scary Halloween walk through the town's 8-acre park. Shown here in 2005 from left to right are Michelle Stein, Lynne Garvey-Hodge, Kathy Kinter, and Jennifer Chesley. (Author's collection.)

The Clifton Town Playground has always been a source of family attraction and fun. Renovated in 2006 under the direction of town councilwoman Trish Robertson, the playground now has new equipment, mulch, and landscaping. (Courtesy Virginia Room, Fairfax City Library.)

In the social event of the year, Jennifer Keen and Mayor Jim Chesley were married on July 22, 2000. Their rehearsal dinner was held at the Hermitage Inn, and their well-attended wedding reception was held at the Heart in Hand restaurant. A beautiful bride, attended by her two daughters, sisters, and close friends, Jennifer has taken on an active role in volunteering in community events. She cochairs the Town Beautification Committee with Lynne Garvey-Hodge. Together they are responsible for the great success of the annual Historic Clifton Candlelight Tour, held the first Saturday of December. (Courtesy Jim and Jennifer Chesley.)

The 2000 Chesley wedding included Jennifer's two daughters, Lauren (left) and Brienne (center). They came to live in "The Mayor's" house and enjoyed their adolescent years in Clifton. Sharing the day at the town caboose was a most memorable way to honor Jim's hard work to make its location a park-like setting for the town. (Courtesy Jim and Jennifer Chesley.)

The Democratic Women of Clifton is a new, energetic, and powerful force. Shown marching here is Donna Netschert in full patriotic regalia, with her other Democratic sister supporters, in the 2006 Fourth of July Clifton parade. The group is credited with helping elect George Barker to the Virginia State Senate, 39th District. (Author's collection.)

This is the winner of Clifton's 2007 Fourth of July parade float contest. Patrick Pline worked for months to construct the "Pline Plane" for children Elliot and Kate. (Author's collection.)

In 2007, George Barker won the Virginia State Senate, 39th District seat. Shown with his wife, Jane, they have been a vocal and energetic presence in Clifton. Jane was a founding member of the Democratic Women of Clifton and extremely active in local civic affairs. (Courtesy Barker family.)

Clifton's 100th anniversary celebration in 2002 was a happy memory for all citizens. Town councilman Wayne Nickum, town clerk Pam Wallace, and Pam's husband, Bob Wallace, served as jurors in the Fourth of July Parade celebration. Wayne is shown here in his favorite and most memorable costume for this type of town event. (Author's collection.)

The 100th anniversary celebration in 2002 included the burial of a time capsule to be opened in 2027. The late Robin Beard and Wayne Nickum are pictured in the living room of Robin's house, the Payne House, packing the contents and artifacts into the capsule. (Author's collection.)

Tom Davis, congressman from Virginia's 11th District, paid a special visit to Clifton's 100th anniversary celebration. Shown with a special T-shirt and balloons, Davis has been a frequent visitor to the town and a great supporter of its preservation efforts. Married to local politician Jeanne Marie Devolites, they make a formidable pair in Virginia politics. The Clifton anniversary celebration was a year in the planning, and thankfully the weather held out for three days of fun, memory making, and sharing. (Author's collection.)

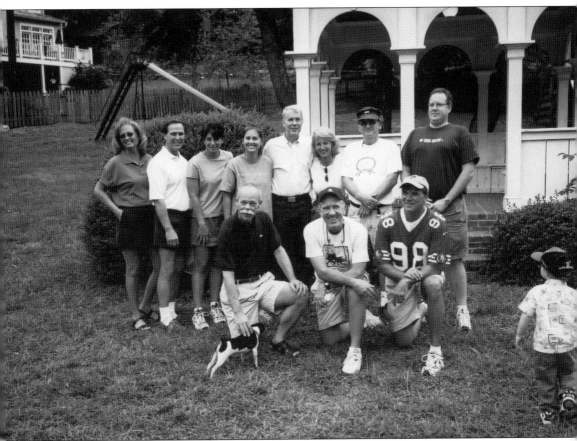

Over 75 volunteers made Clifton's 100th anniversary celebration a success. Over a year in planning, many fun and inspirational meetings led up to the event. From left to right are several key volunteers: (kneeling) Tom McNamara, Robin Beard, and Tommy Peterson; (standing) Jennifer Chesley, Mayor Jim Chesley, town councilwoman Laura Harrington, Michelle Stein (Clifton Betterment Association), town councilman "Mac" Arnold, celebration chairperson Lynne Garvey-Hodge, town councilman Wayne Nickum, and town councilman Bill Holloway. They are shown in front of the town gazebo, erected by the town's Gentleman's Club in 1987. (Author's collection.)

A 2005 heavy winter storm made the Clifton area an oasis in the midst of a beautiful winter wonderland. Traffic was blocked at various spots throughout the county for several days, and Clifton neighbors helped one another dig out. Shown is the Russekrobbins family home. Designed by former Clifton architect Jim Hricko, the home was for a short time a bed-and-breakfast next to the Hermitage Inn. (Courtesy Russekrobbins family.)

The heavy 2005 snowstorm made this magical view of the Pline home on Main Street seem fit for a holiday card. Affectionately called the Miller House, it is a 1907 Victorian farmhouse. The yard still contains a shed with a root cellar for distilling spirits. The remnants of an orchard containing apple, cherry, and pear trees are still part of the property. (Author's collection.)

Clifton suffered an enormous flood in 1936. In 2006 and 2008, the town experienced much higher than usual rainfalls, causing Popes Head Creek to rise and spill over its banks. Here is a picture of the land around the Russekrobbins house on Main Street. In 2006, the Acacia Lodge No. 16 was badly damaged, as were other properties during the storms. The area has suffered because of increased development of land and minimal use of porous surfaces, causing the water to collect and flow into a destructive pattern. (Courtesy Russekrobbins family.)

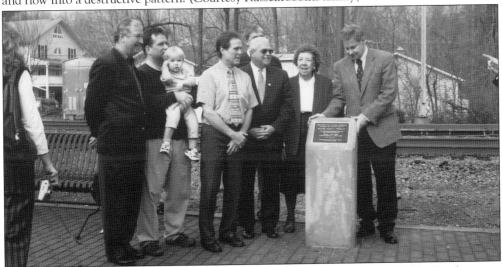

Having served for over 14 years as mayor of Clifton, Jim Chesley was honored by local citizens and political dignitaries in a January 2006 ceremony at the Caboose Park in the heart of town. Many other local citizens have given their time and talent to make Clifton a success. The last town council serving with Mayor Chesley voted to have this plaque installed in the Caboose Park. Shown from left to right are Jim O'Brien, former Virginia State Senate, 39th District; Tim Hugo, delegate for the Commonwealth of Virginia's 40th District; Mayor Jim Chesley; Chairperson Gerry Connolly, Fairfax County Board of Supervisors; Mayor Tommy Peterson (newly elected); Springfield District Supervisor Elaine McConnell; and Congressman Tom Davis from Virginia's 11th District. To Mayor Chesley, Clifton says, "Thank you!" (Author's collection.)

Mayor Tom Peterson (2006–2010), on the left, and former mayor Jim Chesley (1992–2006), on the right, are pictured at the 2007 Fourth of July Clifton festivities. Mayor Chesley's exuberant ability to network locally, state-wide, and nationally achieved a high level of integrity in keeping the historic town clean and safe. He achieved Virginia Scenic Byway status for Main Street, worked with local Boy Scouts to oversee numerous town landscape and trail improvements, and initiated the renovation of the Caboose Park. His good sense of humor and ability to keep town council meetings focused will long be remembered. Mayor Peterson's great "harmonizing" energy launched a committee structure of government, allowing inclusion for all citizens to participate in a variety of town initiatives. During his first year in office, floods destroyed the Eight Acre Park's Buckley Bridge. Within a year and a half, the bridge was rebuilt, allowing resumption of the town's revenue-generating annual Halloween Trail event. Clifton owes a debt of gratitude to both mayors and to former mayor Wayne Nickum for ensuring Clifton is the beautiful, quaint, and historic town it is today. (Author's collection.)

Chairperson Gerry Connolly of the Fairfax County Board of Supervisors is shown addressing a meeting of the Democratic Women of Clifton. A frequent visitor and supporter of Clifton events, Connolly was elected representative for the Commonwealth of Virginia's 11th Congressional District in November 2008. (Courtesy Barker family.)

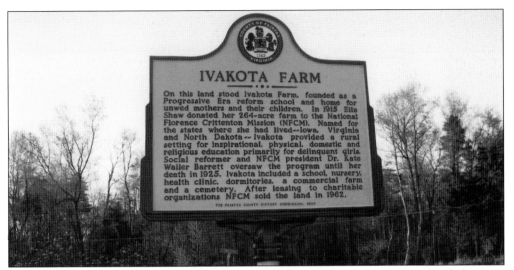

On May 12, 2007, the Balmoral Greens Clifton subdivision enjoyed a historic marker dedication. The Ivakota Farm marker was unveiled among a group of some 75 local politicians and neighbors. The eventful occasion marked the history of the location, Mother's Day, and the Jamestown 2007 celebration. (Author's collection.)

The Ivakota Farm historic marker dedication brought together a host of Dr. Kate Waller Barrett's relatives and friends of Clifton. The farm served as an excellent employer in the area, hiring superb social workers, nurses, and doctors. Farm support was needed to keep the facility running smoothly and the buildings well maintained. During 1940s summers, many area young men worked the fields. Reminiscing occurred the week before the marker dedication with a luncheon held at the Canary Cottage. A local woman wrote a poem dedicated to her grandmother, a resident at Ivakota Farm, later discovering she was related to Stewart Buckley, a longtime friend of the Barrett family. Shown before the May 12, 2007, dedication from left to right are former Clifton neighbors and Barrett relatives Harry and Nena Crouch, Douglas Detwiler, Stewart Buckley, Jack and Charlene Smith, Dorsey Smith, Val Smith, Fairfax County History Commissioner Lynne Garvey-Hodge, and Andy Morse (historian, Balmoral Greens Home Owners Association). (Author's collection.)

The Clifton Village Square Quilters have met for over 25 years and made a number of quilts for town donations. As their children were born, they each made the child a quilt. Shown in May 1999 at Peggy Weed's wedding on the steps of the Hermitage Inn are, from left to right, (first row) Susan Ricci, Peggy Wood, Pam Wallace, and Jean Botts; (second row) Emmi Holmes, Joan Tyson, Brenda Ference, and Ann Wood; (third row) Martha Embrey, Katy Beatty, Linda Boyer, Jan Schneiderman, Diane Dygve, Margo Buckley, and Chris Boorth; (third row) Charlotte Fullerton, Helen Buller, Phoebe Peterson, Tina Krause, and Karen Arnold. (Courtesy Jan Schneiderman.)

Native Clifton resident Randy Thompson has been an avid supporter of Clifton events for years. His skills as a musician are internationally known, and he has been an ardent coordinator of many Clifton events, including the Annual Town Christmas Tree Burning and the Fourth of July Fireworks Extravaganza. He has recorded four CDs of mostly original Americana/Roots music between 1988 and 2008; three were released nationally and in Europe. His music has been played on hundreds of radio stations around the world. He reached the top 40 on national radio charts for Americana, country, and Roots Rock music. In 2004, he reached No. 1 on the European hot disc chart. His latest CD, *Further On*, went all the way to No. 6 on the Freeform Americana Roots (FAR) chart in the United States. He records and plays often with his son Colin on guitar. (Courtesy Randy Thompson.)

Mayor Tom Peterson was married while serving Clifton. The ceremony took place at Clifton's park gazebo on September 24, 2005. The town was invited to the ceremony and celebratory potluck dinner. Shown with his wife, Jean; son, Turner; and daughters, Carleigh and Rachel, the family owns and runs Peterson's Ice Cream Depot—a favorite place for town visitors during the summer months. (Courtesy Peterson family.)

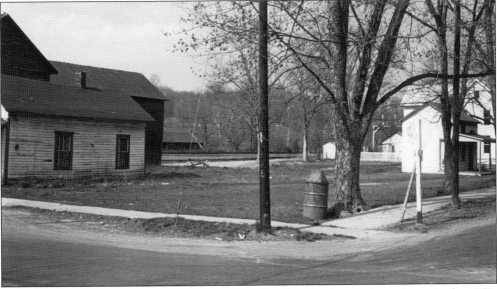

Clifton became a sadly neglected and somewhat abandoned refuge for long-timers in the 1950s and 1960s. Ayre Square is shown in 1960, a reflection of the bleak and sad look the town once carried. The square is now home to numerous events and much improved landscaping. (Courtesy Virginia Room, Fairfax City Library.)

Ayre Square is pictured in 2008. A local Boy Scout troop built a tiered planter around the flagpole that is filled with flowers year-round. The town Christmas tree is lit during the annual December Historic Candlelight Tour. Town Beautification Committee cochairs Lynne Garvey-Hodge and Jennifer Chesley oversee the upkeep of this section of town, recently adding the large flower containers lining Chapel Road. (Courtesy Ed Parker.)

Main Street and the railroad crossing has changed little since 1927, as seen in this photograph recreating the cover image of this book. The Clifton Hotel is now painted yellow and is missing its second-story balcony. The Ambler home is now a Long and Foster building, and the Acacia Lodge is still functioning as such. The author is shown standing in the same spot as Clifton railroad agent Thomas Anthony Ayre is in this book's cover image. (Courtesy Ed Parker.)

BIBLIOGRAPHY

Abdill, George. *Civil War Railroads*. Bloomington, IN: Indiana University Press, 1961.

Kunzel, Regina G. *Fallen Woman, Problem Girls*. New Haven, CT: Yale University Press, 1993.

Mauro, Charles V. *The Civil War in Fairfax County*. Charleston, SC: The History Press, 2006.

Netherton, Nan. *Clifton: Brigadoon in Virginia*. Clifton, VA: The Clifton Betterment Association, 1980 and 2007.

Rozman, Sr. Mary Claude. *Master of Nineteenth-Century Railroad Management: The Life of John Henry Devereux*. Ann Arbor, MI: UMI Dissertation Services, 1987.

Ward, Geoffrey C. *The Civil War*. New York: Random House, 1990.

Val Smith, descendant of Dr. Kate Barrett, took this 2007 photograph on Main Street before the Ivakota Farm marker dedication. The Payne House is now missing its wraparound porch, and you can see the stone cottage at 7155 Main Street, the first home in Clifton to have indoor plumbing. Sitting in the middle is the Canary Cottage Bed and Breakfast, which began operation in 2001.

While the town enjoys a peaceful Fourth of July parade down Main Street each year, the issue of traffic is significant. Some 12,000 cars pass through Clifton daily, and some 36 railroad trains traverse through the town on a daily basis. However, Clifton is the "Brigadoon" of Virginia, and the town believes in 2108 it will look much the same. (Courtesy Val Smith.)

Across America, People are Discovering Something Wonderful. Their Heritage.

Arcadia Publishing is the leading local history publisher in the United States. With more than 4,000 titles in print and hundreds of new titles released every year, Arcadia has extensive specialized experience chronicling the history of communities and celebrating America's hidden stories, bringing to life the people, places, and events from the past. To discover the history of other communities across the nation, please visit:

www.arcadiapublishing.com

Customized search tools allow you to find regional history books about the town where you grew up, the cities where your friends and family live, the town where your parents met, or even that retirement spot you've been dreaming about.